BILL WILSDON was b
1960. His mother's f
near Bangor, and he
Gray, the tragic heroi
interest in the Rebell.
School, he graduated from the University of Manchester
with a degree in geography. He joined the Northern
Ireland Fire Brigade in 1983 and is currently working in
Enniskillen, County Fermanagh. He is married with two
daughters.

BLACKSTAFF GUIDES

The Sites
of the
1798
RISING
in
Antrim and Down

BILL WILSDON

THE
BLACKSTAFF
PRESS

BELFAST

to Diane,
Sophie and Vivien

First published in 1997 by
The Blackstaff Press Limited
3 Galway Park, Dundonald, Belfast BT16 0AN, Northern Ireland
with the assistance of the
Cultural Traditions Programme which aims to encourage
acceptance and understanding of cultural diversity

Reprinted with corrections, 1998

Typeset by Techniset Typesetters, Newton-le-Willows, Merseyside

Printed in Ireland by ColourBooks Limited

A CIP catalogue record for this book
is available from the British Library

ISBN 0-85640-615-5

CONTENTS

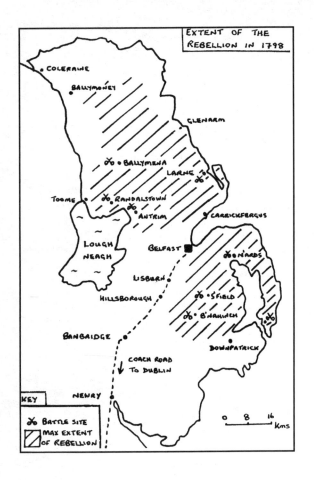

EXTENT OF THE REBELLION IN 1798

COLERAINE
BALLYMONEY
GLENARM
BALLYMENA
LARNE
TOOME
RANDALSTOWN
ANTRIM
CARRICKFERGUS
LOUGH NEAGH
BELFAST
N'ARDS
LISBURN
S'FIELD
HILLSBOROUGH
B'NAHINCH
BANBRIDGE
DOWNPATRICK
COACH ROAD TO DUBLIN
NEWRY

KEY
✗ BATTLE SITE
⬜ MAX EXTENT OF REBELLION

0 8 16
Kms

HOW TO USE THIS GUIDE

This guide has been compiled to accompany readers who wish to further their interest in the extraordinary events associated with the United Irishmen and the Rebellion of 1798 in Ulster. Many sources of information have been used to provide a broad choice of sites, covering a wide geographical area of counties Down and Antrim. It must be stated, however, that I have not attempted to make this a comprehensive survey (if such a feat were possible), nor are all the sites chosen necessarily of a highly significant nature. Instead it has been my intention to provide the reader with a broad spectrum of places to visit which represent both the highly personal and collective aspects of the period in order to provide a wider understanding of the times.

A few words of explanation are required on the layout of this guide. Sites have been grouped together on a geographical basis for convenience into several tours. The length of time to complete each is variable but none would require more than a day trip. Any route can of course be followed and it is not necessary to remain on any single tour. Most sites are identified by an Ordnance Survey (os) sheet number and a grid reference, together with brief directions to the site. The sheet numbers refer to the 1:50,000 maps which now cover the whole of Northern Ireland. However due to the limited geographical extent of the Rebellion and its features, only sheet numbers 5, 8, 9, 14, 15, 20, 21 and 29 are required. For those using the older Third Series 1:63360 (one inch to a mile scale) maps, the grid references are the same and can be used to locate sites. For Belfast city centre, there are several published maps which would be useful and a visit to the Northern Ireland Tourist Board office in North Street would be helpful. In any event, if the reader does not possess the relevant map then it should still be possible to locate sites from the description at the beginning of each

item. And if in doubt, stop and ask for directions; local people are normally only too happy to assist.

Distances along the roads are in kilometres and miles. For smaller distances – for example, within a graveyard or other site – I have used metres only. Many sites require the reader to orientate themselves. It is therefore recommended that a compass be taken along. It is possible to orientate oneself in a Church of Ireland graveyard as it is conventional to situate the main entrance door to the west and the pulpit to the east.

Many of the sites require walking over open ground and, depending on the time of year, the going underfoot may vary considerably. However, a good pair of walking shoes should suffice on all occasions. An entry in this guide is not a guarantee of right of access.

INTRODUCTION

BACKGROUND TO THE
REBELLION IN ULSTER

The causes of the Rebellion of 1798 are rooted in the events which took place in Ireland at the end of the seventeenth century, during the dynastic struggle between James II and his son-in-law William III. In English history, the abdication of the Catholic James and his replacement by the Protestant Prince William is known as the Glorious Revolution, principally due to the bloodless nature of the coup. However, in Ireland the change of monarch resulted in a highly destructive three-year civil war which caused enormous upheavals of population and left a trail of destruction in its wake.

On 3 October 1691 the Treaty of Limerick was finally signed, which signalled the defeat of James's attempt, with French involvement, to regain his throne in Ireland. In the following decades the Protestant parliament in Dublin put in place measures to restrict Catholics from positions of power, influence and wealth, which became known as the Penal Laws. The net effect of the laws ensured that Catholics, because of their active commitment to a Jacobite restoration, were alienated from power in their own country. The measures, enacted over the course of several decades, forbade Catholics from carrying arms, restricted them from higher education, excluded them from practising law and prevented them obtaining a lease of land for longer than thirty-one years. Catholics were also required to take an oath of allegiance before being able to vote and a sacramental test before taking up any public office (thus effectively barring them).

The Penal Laws established the Protestant ascendancy throughout Ireland and were to remain in place until the Act of Union of 1801. Membership of this Protestant

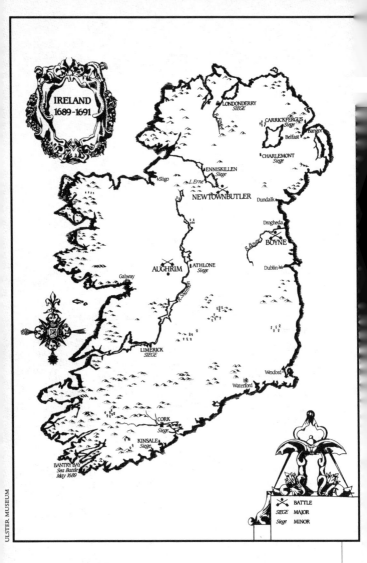

minority, however, consisted only of members of the established Anglican Church in Ireland. Excluded was the substantial Presbyterian population, located mainly in Ulster, known as Dissenters. The Presbyterians frequently argued that they had done most to secure

Ulster for William in 1689 and had thrown in their lot early, unlike other Protestants, who had remained aloof until the issue was nearly settled. They had suffered severe losses and privations during the sieges at Londonderry and Enniskillen and expected the settlement to recognise their efforts. However they were to be disappointed. After 1704, the Test Act, required for public employment and designed ostensibly to deny Catholics, was to exclude Presbyterians from office, notably from the corporations of Belfast and Londonderry, which they had controlled. (The Act obliged the participant to take the sacrament of communion according to the rites of the Anglican Church.)

The exclusion from power of both Catholics and Dissenters was to be a central feature of the ascendancy years of the eighteenth century. The response of Ulster Presbyterians was to seek a new life in the rapidly expanding colonies of North America. This link between the remaining disadvantaged in Ulster and their empowered American relations was to have a profound effect on the politics of the province as the century progressed.

ULSTER IN THE EIGHTEENTH CENTURY

The story of Ulster in the first half of the eighteenth century was one of continuing economic and political disability. Acts of parliament excluding trade in direct competition with British interests ruined many farmers and craftsmen. A series of poor harvests brought famine, and the implementation of the Penal Laws eroded what little political influence remained for Catholic and Dissenter alike. Most galling of all for Presbyterian settlers was their treatment in relation to farm tenancy. In the 1690s a wave of Scots had crossed the North Channel in the wake of the Williamite victory and taken up leases offered by landlords. In the early years of the succeeding

century, these leases became due for renewal and rents often doubled in price. Landlords were happy to accept Catholics as tenants as they were perceived as being more compliant and willing to accept land on any condition, thus undercutting the Presbyterian farmer. This left Presbyterians with the choice of accepting a lower standard of living in order to pay for the increased rent or emigrating to the newly forming colonies across the Atlantic in North America.

The net result was the extensive emigration of much of the Presbyterian population of Ulster to a new life in North America. By contrast, Catholics experienced the same hardships but were to remain and endure their difficulties. The reason for this is due partly to the tradition of emigration by Ulster Presbyterians in the last decades of the seventeenth century to Maryland and eastern Pennsylvania. These new migrants were not heading into the unknown but were strengthening existing Scots-Irish Presbyterian settlements. The great Catholic exodus to America would not occur until the famine of the mid-nineteenth century. In all, perhaps one third of the Protestant population of Ireland emigrated during the years 1731 to 1768, totalling as many as 300,000 persons. By the time of the War of Independence, their descendants formed a substantial and highly motivated group amongst the three million citizens of the American colonies.

In Ulster, despite the handicaps on trade, political power and worship imposed on Catholic and Dissenter alike, conditions were to improve as the century wore on. The gradual spread of three-life leases, known as the Ulster Custom, meant farmers were able to enjoy the benefits of their labours over a much longer period of time and thus land improvement became worthwhile. In 1759 the Cattle Acts of 1667 and 1681, which had excluded Irish cattle from Britain, were repealed, thus allowing for the gradual redevelopment of this aspect of agricultural trade. Furthermore, linen, which had developed as a response to the cattle trade restraint, had now become a

profitable enterprise. Based around the Linen Triangle of Dungannon, Newry and Lisburn, the industry brought great wealth to Ulster.

Another aspect of the linen industry was the need for market outlets, and towns were to develop where white and brown linen was traded. An urban society thus began to take root in Newry, Londonderry and Belfast, with the rise of a merchant middle class of well-educated men who became influenced by the new ideas of the Age of Enlightenment. In Ulster, this new class was Presbyterian.

THE GROWTH OF BELFAST

When the eighteenth century opened, Belfast was merely a small port, situated at the mouth of a sluggish river, which had barely spread beyond the confines of its earthen ramparts thrown up a hundred years earlier. Yet by the end of the century, it had become Ulster's chief commercial centre and was poised to embark on a further century of phenomenal growth which would cause it to rival Dublin for supremacy in Ireland.

With the end of the Williamite Wars in 1691, the population of Ulster was boosted by the arrival of some fifty thousand Scots, predominantly Presbyterians, who were fleeing from religious persecution in their own country. Another influx of migrants was to arrive from the continent when Louis XIV revoked the Edict of Nantes, suppressing the worship of non-Catholics, and caused the Protestant Huguenots to leave France and settle in, amongst other places, north-east Ulster. Importantly, they brought with them their knowledge of the linen trade and found their new environment conducive to the successful growth of flax.

By the mid-century, as Hanoverian power became consolidated, the position of Presbyterians in particular was to improve appreciably. Though still only a town of 8,000 persons, Belfast was also on the brink of a period of

important development involving both its owner, Lord Donegall, and its citizens.

In 1737, Francis Joy, grandfather of Henry Joy McCracken, established the *Belfast News-Letter and General Advertiser* at offices in Bridge Street. As a result, he opened a paper mill at Cromac in 1767, now the junction of Ormeau Road and Ormeau Avenue, to provide for his growing publishing needs. In 1777, Francis's son, Robert, introduced the cotton industry to Ulster and in 1784 the partnership of Joy, McCabe and McCracken opened the first water-powered mill in Ireland to spin and weave cotton. The industry flourished and by 1790 an estimated 8,000 persons were employed in cotton manufacture in a 24-km (15-mile) radius around Belfast. In 1783 a Chamber of Commerce was established which invited a Scots shipbuilder, William Ritchie, to establish a ship-building yard at the Old Lime Kiln Dock, the forerunner of Belfast's shipbuilding industry.

New places of worship were also erected. In a town of mainly Presbyterian citizenry, Rosemary Lane (now Street) contained three congregations and a new meeting house was built for the First Presbyterian congregation in 1782 to the design of the eminent architect, Roger Mulholland. This superb elliptical building with its wooden box pews and a gallery above carried on wooden Corinthian columns, still remains. The first Catholic church was erected in Chapel Lane in 1784 and the first Methodist church in Fountain Lane in 1787.

Lord Donegall embarked on developments of his own. In 1752 he opened the Brown Linen Hall, a market for the exchange of brown or unbleached linen products. In 1767 he erected a single-storey exchange building, adding an upper storey eight years later to provide much needed assembly rooms, and in 1774 he erected St Anne's parish church in Donegall Street. Later in the century he developed Linen Hall Street (now Donegall Place), employing Roger Mulholland to design superior terraces for the upper classes of the town.

The citizens of the town were also keen to improve

Belfast. In 1752 they established the Belfast Charitable Society whose object was to provide relief for those in poverty. The result was the poor-house, completed in 1774, and still in use as a residential home. The White Linen Hall, for the sale of bleached linen products, was erected in 1784 and allowed the city to take control of this lucrative market. A Fever Hospital was opened in 1797 in Factory Row (now Berry Street).

All of these improvements were carried out in a town whose population, by the end of the century, was still under 20,000 inhabitants. It was not surprising, then, that this enterprising and innovative centre should also play host to the latest ideas in political thinking and it was here that the concept of the United Irishmen was born.

THE IRISH PARLIAMENT IN THE EIGHTEENTH CENTURY

The constitutional position of the Irish parliament in Dublin was indeed an unusual one. Its ability to originate legislation had been substantially curtailed by Poynings' Law of 1494 which held that all Irish bills had first to be ratified by king and council in England, where it might be approved, with or without modification, or suppressed altogether. This position had not been altered by the Treaty of Limerick in 1691. For the next half-century, the Irish parliament was therefore perceived as an inferior tier of government, remaining accountable to the supreme parliament at Westminster.

However, as the Anglican ascendancy grew in self-confidence in the latter half of the eighteenth century, this position was inevitably challenged. From the 1750s, an opposition grouping began to emerge in parliament called the Patriot Party, under the leadership first of Henry Flood, then of Henry Grattan, which agitated for change in the name of the 'Protestant Nation'. Reformers such as Grattan and Flood were keen to relax the restrictive practices placed on Catholics and Dissenters and to

extend the franchise to freeholders. But for every reformer amongst the Patriots there was a conservative who urged caution, arguing that encouraging the inclusion of Catholics into positions of power would threaten the ultimate security of the Protestant ascendancy. Protestants were aware that they could never sever their relations with Westminster and declare independence without losing their unique position of privilege within Ireland.

THE VOLUNTEER MOVEMENT

Protestant sympathy for the cause of reform was tempered by the uncertainty of how such change might affect their own position of privilege. Though most believed that change should occur, there was no clear understanding of just how far reform could be taken. However, events were to overtake Ireland in the final quarter of the century which would have a profound effect on the cause of reform. In 1775, Britain found herself at war with her American colonies concerning issues familiar in Ireland – freedom from the restrictions of government and trade. There was thus a great sympathy for the American colonists in their struggle, especially amongst the Presbyterians of Ulster.

As the war progressed, the garrisons of Britain and Ireland were emptied of troops to provide armies in America. The news of General Burgoyne's surrender of 5,700 British troops at Saratoga in October 1777 was followed by the entry of France into the war on the side of the colonists in 1778. The Spanish joined the French the following year and Britain found her army and navy stretched. The vulnerability of Ireland to invasion was amply demonstrated in 1778 by the renowned Scots-American sailor, John Paul Jones, who sailed his privateer *Ranger* into Belfast Lough, attacked and captured the British warship HMS *Drake* and made off with his booty; he molested British inland shipping and created havoc

for months to come. Clearly there was a need to enlarge and reinforce Irish garrisons. The Irish Privy Council had sufficient stocks of arms and ammunition to mobilise a militia but they failed to move quickly on the matter.

In the event, the issue of an armed force was quite literally taken out of the hands of government by the formation on 17 March 1778 of the Belfast Volunteer Company, although from 1777, and in some cases earlier, Volunteer companies were being formed in various parts of Ireland. A statement issued by the Belfast Company asserted its independence from government control. Further companies were formed and several of them followed Belfast's lead of asserting the philosophy of independent armed service. The companies offered to defend the country and, as the threat of invasion increased in the summer of 1779, the Irish Privy Council was obliged to issue militia arms to Volunteer companies. In October, with the fear of invasion past, a grateful parliament issued a vote of thanks to the Volunteers, but carefully avoided a discussion of the legality of the Volunteer movement.

Whatever the position of the Volunteers, these actions had earned them respectability, and several aristocratic figures and members of the gentry joined the organisation. James Caulfield, Earl of Charlemont, was invited by the Volunteers to become their chief. It was now clear that this independent body could be used to agitate for political causes – had they not earned this right by their loyal defence during the summer of 1779? On 4 November 1779, a demonstration of armed Dublin Volunteers under the leadership of Lord Leinster demanded 'Free Trade or This' (referring to a cannon around which the slogan was hung). Patriot members of parliament, most notably Grattan and Flood, aware of the political opportunities which existed in making use of this armed extra-parliamentary force, now campaigned vigorously for their twin demands of free trade and parliamentary independence. An alliance between the 'patriotic'

element in parliament and the Volunteer movement developed in the succeeding months and years, and forced the government to concede to certain of the demands of parliament. In the sphere of trade, legislation in 1778 removed the Navigation Acts of 1663 and 1670 which had discriminated against Irish mercantile marine by refusing them permission to trade with the empire. The restrictions on the export of wool, woollen cloth and glassware were similarly abolished.

The period of the American War of Independence thus became one of great legislative opportunity in Ireland. In 1778, the first Catholic Relief Act allowed Catholics to take out indefinite leases on property. It was followed in 1782 by a more wide-ranging second Catholic Relief Act which granted Catholics the right to buy, sell, bequeath and mortgage freeholds in the same way as Protestants. The Penal Laws on education, ownership of arms and on priest registration were abolished. Presbyterians were also able to benefit when the Test Act was repealed in 1780, which now meant that they were no longer excluded from holding office in borough corporations.

The high point for the Volunteer movement occurred in February 1782 when a convention of representatives of all companies was called at Dungannon. By now the movement numbered over 35,000 in Ulster alone and also comprised units of artillery. Dungannon was chosen as it was the geographic centre of Ulster; it was also close to the Earl of Charlemont's power base near Moy, County Tyrone. After much heated debate the convention passed resolutions which called for legislative independence, stating that 'the claim of any other than the King, Lords and Commons of Ireland to make laws to bind this Kingdom is unconstitutional, illegal and a grievance'.

Under political pressure and the threat of armed intervention the British parliament was forced to act. Lord North's ministry fell in March 1782 and was replaced by Rockingham's Whigs. In May, the Declaratory Act of 1720 was repealed, along with much of Poynings' Law.

This gave the Irish parliament the right to pass laws in Ireland, without interference of the British parliament at Westminster, and established the independence of the Irish judiciary. A Renunciation Act followed in 1783 which confirmed the new independence of the Irish parliament and relinquished England's power to revive legislation which could abolish these concessions, stating that 'the right claimed by the people of Ireland to be bound only by laws enacted by his Majesty and the parliament of that Kingdom, in all cases whatever shall be, and is hereby, declared to be established and ascertained for ever, and shall at no time hereafter be questioned or questionable'.

The reformers had triumphed. A new constitution had been established and the Irish parliament was now independent for the first time in three hundred years. This period of independence, which was to last only eighteen years until the Act of Union, is commonly termed 'Grattan's parliament', in honour of the principal figure who agitated for it. In fact Grattan was never part of the government but remained the focal point of continuing reform.

The Volunteer movement was now at a crossroads in its existence. The surrender of Cornwallis at Yorktown on 19 October 1782 effectively ended Britain's war in North America and was followed on 3 September 1783 by a recognition of the independence of the United States in the Treaty of Paris. The end of the war also ended the justification for the Volunteers' existence as the threat of invasion had now passed. Furthermore, the government was becoming increasingly alarmed at the military threat posed by the Volunteers. Though expressing their loyalty to the Crown, they were politically anti-government and beyond the control of parliament. Parliamentarians were anxious to reassert their role as the sole means for achieving reform and Grattan was also anxious that, having established the constitution of 1782, Volunteer involvement in politics be restrained in order to allow time for the new arrangement of government to develop.

The future for the Volunteers was therefore uncertain
and the leadership was divided as to the programme of
continuing demands. Charlemont, for one, believed that
much had already been achieved and that further changes
were unnecessary, but radicals such as the Earl Bishop of
Derry demanded further change. In 1783, at a national
convention in Dublin, speakers continued to agitate for
electoral reform, demanding annual parliaments, secret
ballots, disenfranchisement of rotten boroughs and an
extension of the franchise.

When parliament rejected the proposals, the Volun-
teers were forced to accept defeat. The only alternative
was to bypass parliament, and that meant civil war. From
1784 onwards, the power of the Volunteers declined
rapidly as the aristocracy and gentry, who had previously
provided leadership, left in droves. In an attempt to stem
this drain, the movement opened its doors to the lower
classes, artisans, farmers and the like. Catholics were per-
mitted in many cases too. But their power to demand
change had slipped away for ever.

The remaining years of the decade were characterised
by a failure to agree on a programme of continuing
reform. No single issue arose to focus the attention of
the reformers. Despite this, the desire for change
continued to dominate political life. Though Grattan
and Charlemont had managed to achieve much, they
had awakened a nation to the potential for resolving
further, long-standing grievances.

FROM IRISH INDEPENDENCE TO
FRENCH REVOLUTION

With the Renunciation Act of 1783, and the apparent
establishment of parliamentary independence, the
Dublin parliament should now have looked forward to a
golden era of social and political opportunity and a bright
future of expanding trade and commerce under the
protective arm of the British Constitution. Yet ultimately,

this new-found freedom would last a mere eighteen years and lead to the abolition of home government in Ireland. The causes of this failure can be traced to the incomplete and unsatisfactory conclusion of this first revolutionary period.

In any age, government may be viewed by society as old-fashioned, redundant, conservative or corrupt. Agitation for change becomes most effective when popularly perceived grievances can be focused into a single or strictly limited set of demands. Once a sufficient groundswell of support is created, revolution achieves the required momentum to overcome the inertia of conservatism. Such was the situation in Ireland in 1783. For aristocratic reformers such as Charlemont, the wresting of independence from England had achieved the aim of the revolution and what was now needed was a period of quiet reflection in which the new independent parliament could begin to develop its own structures and the procedures required for the weighty task of government. What Charlemont had not foreseen, or at least not fully appreciated, was the nature of revolutionary change itself. For once active, revolutionary movement acquires a life of its own, and cannot be turned on or off at will.

Amongst the Presbyterian merchants of Belfast, the tenant farmers and petits bourgeois of Antrim and Down, the debate regarding the ultimate outcome of the revolution differed significantly from the landed interest of the Anglican establishment. The former had listened to and approved the argument that Irishmen should legislate for themselves, free from external interference. But the mere transfer of power from an unelected British establishment to an equally unrepresentative Irish one was not their ultimate goal. Parliamentary independence was only part of their aims, not all of it. They wanted the right of all Irishmen to determine their elected representatives in a fully reformed parliament. An expectation of change had been created but a lack of focus was to plague the reformers' cause for the rest of the decade, and no single issue would emerge for all to

unite behind. Instead a broad spectrum of grievances was presented by different factions and interest groups, with parliamentary reform and emancipation the main concerns.

Although the Irish Commons contained three hundred elected representatives, only around seventy were freely contested. The remainder were returned under the influence of important magnates or landed interest, so-called 'pocket' borough elections, where candidates were assured of an election result and thus a seat in parliament. For the Presbyterian merchants, who had largely created Belfast and its prosperity, there was obvious resentment at this lack of democratic accountability of persons deemed to be representing their interests in parliament. A petition to the Irish Commons in 1784 complained of the lack of democracy in the town despite returning £80,000 annually to the public purse.

Catholic emancipation was also supported by the radical Presbyterians of east Ulster. Dublin barrister Theobald Wolfe Tone would later comment that the citizens of Belfast were 'wonderfully ignorant of their Catholic brethren'. This observation was supported by the fact that Catholics were only a small minority of the population in Antrim and Down and therefore presented little threat to the political ambitions of the Presbyterians. However in the rest of Ulster, the division was always much more finely balanced and the granting of emancipation to Catholics was greeted with greater caution. Over much of the rest of Ireland, Protestants were numerically insignificant and the fear of a Catholic-dominated parliament sent shivers down the spine.

As a result of the uncertainty which future reform might bring, men such as Charlemont were to retire from the front ranks of the Volunteers and concentrate on consolidating their newly won gains. In 1784 the ranks of the Volunteers were at last opened to Catholics and it was from the middle class that the new recruits were eagerly enrolled. On 13 May of that year the Belfast First Volunteer Company agreed to instruct persons of all ranks and

religious persuasions in the use of arms and they were followed soon after by the Builders' Corps Company in Dublin. Tolerance of Catholics in Belfast was further strengthened when the Volunteers of the town attended the opening of the first Catholic chapel on 30 May 1784.

A national convention in Dublin in 1783 lobbied for 'a more equal representation of the Commons of Ireland'. The representatives for Belfast were the Reverend Sinclair Kelburn and Henry Joy Jr, owner of the *Belfast News-Letter*. The political course chosen by these two men in the next decade would be symptomatic of the debate raging between those who wanted immediate reform and those who preferred a gradualist approach.

So, despite the continuing clamour for reform throughout the 1780s, the landed interest, though still publicly supportive of reform, was privately attempting to take the heat out of politics. History has been unkind to these lukewarm reformers, and critics have pointed to the events of the following decade as proof of their short-sightedness. Yet it is possible that Charlemont's vision could have ultimately been successful if the Irish parliament had been given time to reform itself. The French revolution of 1789 destroyed that chance.

THE SOCIETY OF UNITED IRISHMEN

Henry Flood's appearance in parliament on 29 November 1783, dressed in Volunteer uniform, with the list of demands agreed at the national convention, was to prove the crucial turning point in the history of the Volunteers. To his parliamentary colleagues, Flood appeared to be presenting his proposals at gunpoint and his cool reception and the later overwhelming vote against them signalled the end of the Volunteers' hold over parliament. Either the Volunteers would have to accept parliament's decision or oppose it by use of force.

Around this time, a newly qualified obstetrician was beginning to formulate ideas for a new movement which

would take on board the reform programme of the
Volunteers and carry it forward to its conclusion. Born
in 1754, William Drennan was the son of the Reverend
Thomas Drennan, the former minister of the First Pres-
byterian congregation in Belfast. Drennan wished to set
up practice in Belfast but as the town was already served
by several eminent doctors, he moved to Newry in 1784
and then to Dublin in 1790. As with many other profes-
sional men of his time, he had a keen interest in
the political affairs of the day and was an enthusiastic
Volunteer.

Frustrated by the failure of the 1783 convention in
Dublin, Drennan had come to the conclusion that the
only way in which reform could be achieved would be
by a complete separation of Ireland from Britain. This
separation would be achieved by the union of Irishmen
taking on the Protestant ascendancy, which was unwill-
ing to carry out the programme of reform. As early as
1784 he proposed a new society which would carry for-
ward the demands for the radical reform of parliament
which the Volunteers had ultimately failed to deliver. It
was to be 'a society as secretive as the Freemasons' which
would require of its members 'an oath of admission'. This
new society would exist as an inner circle of radical re-
formers within the Volunteer movement. Later, in May
1791, Drennan would outline the form of the society in
greater detail, proposing it be named the 'Brotherhood'
which would give it 'much of the secrecy and somewhat
of the ceremonial of Freemasonry' to engender 'curios-
ity, uncertainty, expectation in the minds of surrounding
men'. When Wolfe Tone read Drennan's proposals he
suggested the title be changed to 'Society of United
Irishmen'.

Thus Drennan's ideas were to provide a new focus for
the radical movement at a time when their fortunes
seemed to be waning. They had already been given some
encouragement by events surrounding the Fall of the
Bastille in Paris on 14 June 1789. The French Revolution
was reported in the local newspapers and its course was

followed with approval by the reformers. In early 1790 the dormant Volunteer companies were reactivated and began to agitate for the changes denied them in the previous decade. On 14 July 1791 the Belfast Volunteers paraded in the town to celebrate the second anniversary of the Bastille's Fall and ended the day with a banquet in the White Linen Hall where messages of support were proposed for the revolutionaries, agreed and despatched to France. The mood for change appeared again to have gripped the country. During that spring and summer, a secret committee of Volunteers was apparently formed at an inn belonging to Peggy Barclay in Sugarhouse Entry, off High Street in Belfast. Several meetings took place to establish a new society based on Drennan's ideas. All of its members, save one, were prominent and successful businessmen in the town. The exception was a southern Irish Anglican, Thomas Russell, who had been posted with his regiment to the town and had become closely involved with the committee's radical activities. Russell was a close friend of the Dublin barrister, Wolfe Tone, who had published a pamphlet entitled *An Argument on Behalf of the Catholics of Ireland* supporting Catholic emancipation. The pamphlet impressed the committee and Wolfe Tone was invited north in October 1791 to help found the first Society of United Irishmen at Peggy Barclay's.

Throughout the following weeks and months, many other societies were formed in Antrim and Down, usually in areas populated by Presbyterians. A society was also formed in Dublin with Drennan, then practising in the town, as its first chairman. Drennan produced a Test of Membership which was agreed by the society:

> I ... in the presence of God do pledge myself to my country that I will use all my abilities and influence in the attainment of an impartial and adequate representation of the Irish nation in Parliament; and as a means of absolute and immediate necessity in the establishment of this

> chief good of Ireland, I will endeavour, as much
> as lies in my ability, to forward a brotherhood of
> affection, an identity of interests, a communion
> of rights and a union of power among Irishmen
> of all religious persuasions, without which every
> reform in Parliament must be partial, not
> national, inadequate to the wants, delusive to
> the wishes and insufficient for the freedom and
> happiness of this country.

In January 1792 twelve of the radicals, including several of
the original committee of the first Society of United
Irishmen, launched a newspaper, the *Northern Star*, which
was to become the organ of the society. Its first editor and
largest shareholder was Samuel Neilson, a successful
woollen merchant from Belfast.

In this early constitutional phase, each society con-
sisted of up to thirty-five members. Once this figure was
surpassed, a new society was formed. The main aim,
however, was not to expand numbers but to disseminate
their creed to a wider audience – hence the importance of
using existing masonic lodges, Presbyterian congrega-
tions, Volunteer companies and so on, to promote the
radical cause. The organisation was structured along
democratic lines which betrayed the Presbyterian nature
of its founders. Societies held meetings on a weekly basis
and resolutions passed were initially similar to those
passed by the Volunteers at their conventions in the pre-
vious decade: a complete reform of parliament, Catholic
emancipation and a fair representation of all Irishmen was
demanded.

The pressure for change continued with a town meet-
ing in Belfast in January 1792 which met in the Third
Presbyterian church to consider a petition to parliament
calling for immediate Catholic emancipation. Given the
strength of feeling in Belfast it seemed that the radicals
would have their way. In fact the meeting acknowledged
the appearance of a growing rift within the ranks
between those who wanted immediate reform and those

who were willing to achieve it gradually. The latter grouping introduced an amendment for emancipation to be granted 'from time to time, and as speedily as the circumstances ... of the Kingdom will permit'. The amendment was defeated and over six hundred signed the original petition, but it had demonstrated that a sizeable minority was now actively engaged in pursuing a more cautionary approach. A similar town meeting in July that year further indicated a hardening of attitude between these two camps.

Drennan called for a new convention to meet in February 1793 with an agreed programme of demands, but this was overtaken by events. In January 1793 Louis XVI was executed and a 'Reign of Terror' began in France. Suddenly the revolution in France had shifted from democracy to anarchy. This was certainly not the model previously admired by the radicals. In February 1793 Britain declared war against France and the radicals were at a crossroads. Would they support their own country or France?

THE DRIFT TO REBELLION

With war declared against France, the Irish government acted swiftly to seize the initiative from the radicals and take control of the political situation. To achieve this they applied both carrot and stick. The third Catholic Relief Bill was passed in early 1793 giving Catholic forty-shilling freeholders (the property qualification required to vote at an election) the vote and removed from Catholics the restrictions from practising law. Restrictions on entering parliament or holding certain top civil and judicial appointments remained in place. Though not full emancipation, the government hoped to appease the middle-class Catholics of Ireland, at least in part, and prevent them engaging with the United Irishmen.

Parliament then acted to suppress the Volunteers. A

Convention Bill was passed which made assemblies of persons presenting petitions to parliament illegal. Though not naming the Volunteers, this clearly spelled the end of their parades, assemblies and agitation for reform. The outraged William Drennan published *An Address to the Volunteers of Ireland* in the *Northern Star* in December 1792, supporting the Volunteers' right to demand reform. For this he stood trial in May 1794, charged with seditious libel. Despite his eventual acquittal, the incident unnerved him and he gradually removed himself from the forefront of the radical movement.

A Militia Act followed in June 1793 which established county-based regiments to 'strengthen the civil power and to protect the land', that is, to be both a police force and an army. Unlike the Volunteers, the militia remained strictly within the control of the state. Commissions were issued by the government and the cost of the militia's upkeep and training came from the exchequer. Fifteen thousand troops were raised initially, increasing to twenty-two thousand a few years later. Next, a Gunpowder Act forbade the import of arms and ammunition and required persons to obtain a licence to keep firearms.

The government now had the means to suppress dissent and appeared willing to use their new powers. For the reformers there were two options. They could accept there was little chance of further reform under the conditions of war and align themselves with the government by showing support for the war effort against the French. The other option was to seek external help in order to overthrow the government and set in motion a revolution along the lines of the French model. In the event, some of the radicals chose the latter course, and when the Society of United Irishmen was finally outlawed in May 1794, it had evolved into a movement to overthrow the establishment. The gradualists eventually supported the government and subsequently joined the newly forming Orange Order.

The last vestiges of hope for a peaceful resolution were extinguished by events in 1795. In January a new lord lieutenant, Earl Fitzwilliam, was appointed who appeared sympathetic to the call for full, immediate Catholic emancipation. However he was withdrawn in March, having snubbed too many of the establishment with his own political appointments. In May, sensing the inevitable slide to rebellion and the failure of a gradualist approach to reform, Henry Joy relinquished ownership of the *Belfast News-Letter*. In this year too, the United Irishmen made contact with the French and began negotiations for the landing of a French army in Ireland. The plot was eventually uncovered and Wolfe Tone, who was implicated, was forced to flee the country in June. This was not before he climbed Cave Hill, outside Belfast, and together with several of the original founders of the United Irishmen pledged their lives to break the British connection.

Meanwhile in Armagh, the sectarian unrest that had simmered since the 1770s broke out into armed clashes between rival agrarian gangs. On 21 September 1795, at a tiny crossroads in north Armagh, Protestant Peep o'Day Boys clashed with Catholic Defenders and routed them, killing over forty. From this victory the Orange Order was established. It was to act as a focus for Protestants in middle Ulster and would prevent any rising by United Irishmen taking place in these counties in 1798.

The government clamp down continued. In 1796 the Insurrection Act was passed which allowed the lord lieutenant to proclaim an area affected by civil unrest and send offenders to serve in the Royal Navy. Courts were also empowered to try those administering illegal oaths and to impose capital sentences. An Indemnity Bill followed which exonerated magistrates who had exceeded their powers in the course of their duty. In June, a yeomanry was established to support the existing regular and militia troops.

In September numerous arrests of known leaders of the United Irishmen took place. Though a large French

fleet appeared off Bantry Bay in December 1796, it failed
to land the fifteen thousand well-armed troops on board
and the greatest opportunity of foreign intervention to
aid the United Irishmen was lost. In early March 1797,
General Gerard Lake was sent from Britain to Ulster to
disarm the population and this he carried out with a
vengeance. Despite the vocal opposition to his methods,
Lake was successful in arraigning massive quantities of
arms and ammunition and forcing the United Irishmen
onto the defensive. Much of the credit for the defeat of
the Rebellion the following year can be attributed to
Lake's earlier groundwork.

THE REBELLION IN ULSTER AND
THE ACT OF UNION

Despite this setback the United Irishmen remained
hopeful of further French intervention and plans were
made for an uprising to take place throughout Ireland
on 23 May 1798. By now the government had success-
fully penetrated the organisation, even to the level of its
provincial directorate, and were aware of the plans.
Numerous arrests in Dublin in March 1798 removed the
southern leadership and left the organisation bereft of its
upper rank. When rebellion at last broke out on 23 May it
was limited initially to the counties around Dublin and
swiftly quashed. Later that month a rebellion broke out
in Wexford which took on an ugly sectarian character
and discouraged many of the faint-hearted in Ulster from
taking part. Only in Ulster was there to be a rising along
the principles of the United Irishmen. Here the Presby-
terian businessmen who controlled the Society were
reluctant to commit themselves to insurrection without
the promise of foreign aid. At a meeting of the County
Antrim colonels in early June, no agreement could be
reached on the date of a planned rising, despite the fact
that a rebellion had broken out in Leinster two weeks
earlier. In the end, the commander-in-chief for County

Antrim resigned and an agreed replacement could not immediately be found.

On 4 June, following a meeting of the County Antrim leadership on Ballyboley Mountain near Larne, it was resolved to await French support. When the meeting broke up, several of the leadership returned to Ballyeaston village where a large assembly of the lower ranks had gathered. News of the indecision was greeted angrily and this more militant element elected Henry Joy McCracken as their leader. McCracken immediately set the date of rebellion as 7 June and called on all the local United Irish units to rise up on that day and seize their local garrisons. He called for a large concentration to gather on Antrim town where Lord O'Neill had called together a meeting of the County Antrim magistrates. McCracken planned to seize them and use them as bargaining counters. Meanwhile in County Down, the United Irish leadership had been thrown into disarray by the arrest on 5 June of the Reverend William Steele Dickson, their commander-in-chief. No successor could be found in the interval and fatally the United Irishmen were to rise in County Down two days later than their counterparts in Antrim. General George Nugent, commander of all government forces in Ulster, was thus able to deal with each outbreak separately and within a week the Ulster United Irish Rebellion had been put down.

The rebellion in Wexford was finally put down when the insurgents were defeated at Vinegar Hill on 21 June 1798. The French belatedly landed a small expeditionary force in County Mayo in August under the command of General Jean Humbert. This force was initially successful but was eventually surrounded and forced to surrender at Ballinamuck in County Longford on 8 September 1798. In October Wolfe Tone was captured while serving on a French ship in Lough Swilly and brought to trial in Dublin. Though he wore the uniform of a French officer, he was court martialled and sentenced to hang. However, he took his own life before the sentence could be carried out.

With the United Irish Rebellion defeated, it appeared that the Protestant ascendancy had managed to triumph over its adversary. However, it was now apparent to the government in Britain under Prime Minister William Pitt that the Irish parliament, through the power of the ascendancy alone, would be unable to maintain the link between Britain and Ireland. Pitt's solution was to propose a union of the two countries by dissolving the Irish parliament and transferring the constituency representation to the parliament at Westminster.

In the months following the Rebellion, the Irish executive set about winning over a sufficient majority of Irish MPs (through massive bribery) to bring about the necessary demise of their parliament in Dublin. This was achieved by a narrow majority in 1800 and the resulting Act of Union came into force on 1 January 1801, whereby Irish interests were represented by one hundred MPs in the British House of Commons and thirty-two peers and bishops in the House of Lords at Westminster. This was to be the beginning of a new era in British–Irish relations.

BELFAST CITY CENTRE

The city of Belfast today retains very little of its eighteenth-century fabric. Now a regional centre and provincial capital with a population of 280,000 (1991), it was in 1798 an important if compact trading port of less than twenty thousand persons. In the nineteenth century the town grew rapidly into an industrial and commercial powerhouse, built upon the twin pillars of shipbuilding and linen, giving the appearance of a late Victorian/Edwardian city that it still has today. By 1900 it was challenging Dublin as the chief city of Ireland. Nevertheless, some elements of the late Georgian period remain and merit closer examination. The walking tour of Belfast city centre begins at the City Hall.

THE WHITE LINEN HALL

The City Hall, completed in 1906, occupies the site of the former White Linen Hall which had been constructed on the five-acre site between 1783 and 1785. The land was donated by the Donegall family and had formed part of the old cherry garden of Belfast Castle, burned in 1708.

The White Linen Hall consisted of a two-storey quadrangular building surrounding a courtyard area where a market for bleached (white) linen was held. It allowed Belfast merchants greater control over the linen industry and secured the town's supremacy in the nineteenth century. In 1802, the Belfast Society for Promoting Knowledge, later known as the Linen Hall Library, occupied rooms in the building. It moved across the road to its current premises in 1898 when the Linen Hall was demolished to make way for the City Hall.

This site, outside the limits of the old town walls, was just beginning to be developed in the 1790s. Large rows of

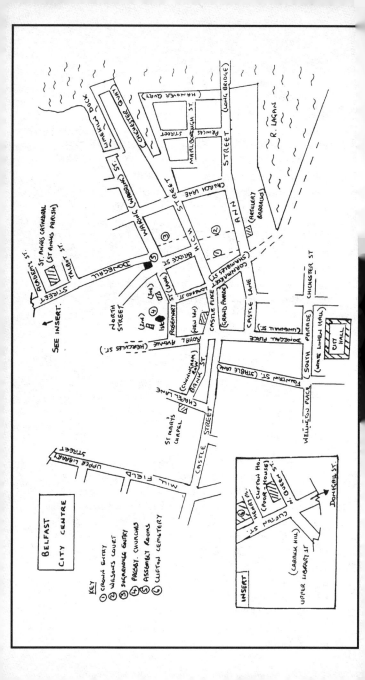

superior, four-storey terraces were erected along what is now Donegall Square North in the direction of Chichester Street and Wellington Place. The street was then known as South Parade, as it lay south of Grand Parade (now Castle Place), and the intention was to create housing for the élite of the town. Wellington Place was originally known as Upper Chichester Street before being named after the eponymous duke.

Although built in 1804, a little later than our period, numbers seven to eleven Chichester Street are nevertheless good surviving examples of the late-Georgian four-storey terraces which existed at the time. Large residential squares surrounding a green area were highly fashionable in Dublin, Bath and Bristol, and Belfast was to attempt several of its own with only modest success: here in Donegall Square in the 1790s, at College Square in the 1820s and 1830s and at Lower and Upper Crescent in the 1850s.

LINEN HALL STREET

Cross the main thoroughfare of Donegall Square North into Donegall Place (formerly Linen Hall Street). Stop outside number twenty-five, about midway along the west side of the street.

Donegall Place today forms part of the commercial and retailing axis which spreads along to Royal Avenue. However, in the 1780s the street was laid out with four-storey terraces for the upper classes of the town. The architect, Roger Mulholland, was commissioned by Lord Donegall to build these houses which were less ornamental than their equivalents in Dublin. The intention was that the street would connect the established Grand Parade (now Castle Place) with the newly erected White Linen Hall.

From the beginning, notable residents occupied the houses in the street. By 1785, John Brown's house stood on the corner with Donegall Square North (see pp. 76–7) and the second Marquess of Donegall lived further along

the rows of terraces between 1802 and 1820. William Sinclaire, a founder of the United Irish Society in 1791 and a successful linen merchant and bleacher, lived near the corner with Castle Lane. His brother John, another United Irishman, lived on the west side of the street, opposite William, and was said to keep a pack of hunting hounds and a monkey in the house. He died in 1857 and was reputed to be the last of the original Belfast Volunteers of 1778. Dr James McDonnell, the eminent surgeon, was to be the last private resident in the street.

Only number twenty-five survives of these late-eighteenth-century terraces and here extensive remodelling of the façade has taken place. The remainder were swept away by later Victorian redevelopment, which transformed the street from residential to commercial premises.

CROWN ENTRY

From number twenty-five Donegall Place cross the road and proceed down Castle Lane to Arthur Square. This section of the inner city has been pedestrianised in recent years. From Arthur Square proceed down Ann Street and turn left just past number six (Woolworths) into the narrow alley of Crown Entry. The former Belfast Castle of the Donegall family was located between Castle Lane (known as Stable Lane up to the 1780s) and Castle Place until destroyed by fire in 1708.

Crown Entry is cited by many authorities as the site of the public house where the first meeting of the Society of United Irishmen took place on 14 October 1791. With one exception, Thomas Russell, the elected committee were all Presbyterian businessmen from Belfast. They were William Simms, Robert Simms, William Sinclair, Samuel McTier, William McCleery, Thomas McCabe, Samuel Neilson, Henry Haslett, William Tennant, John Campbell and Gilbert McIlveen. They elected William Simms as their first secretary and listened to their invited guest speaker, Wolfe Tone, address them on the subject of electoral reform, including Catholic emancipation.

Other societies were soon to spring up in the Presbyterian heartland of Antrim adjacent to Belfast. On 19 December a society was formed at Templepatrick, followed in the next few days by others in Doagh, Randalstown, Killead and Muckamore. The first society in County Down was established in Saintfield on 16 January 1792.

The idea of this form of society had first been mooted by Dr William Drennan and the original aim was to press for further reform of the constitution of 1782, including proposals for annual parliaments, universal suffrage and the removal of the property qualification necessary to entitle a man to be a political representative. But following the withdrawal of the reforming Lord Lieutenant Fitzwilliam in early 1795 and the introduction of restrictive measures such as the Insurrection Act of 1796, the organisation was forced underground and became a secret society. From this point, independence from Britain was viewed as the only solution to achieving their aims.

ANN STREET
ARTILLERY BARRACKS

Coming back onto Ann Street, the site of the former Artillery Barracks (now Littlewoods) is located on the opposite side of the street.

Ann Street is one of Belfast's oldest streets. It was known originally as Back Street (High Street was then Front Street). Later it was known as Ann Lean and, confusingly, in the mid-eighteenth century as Bridge Street because it led to the Long Bridge across the River Lagan. However, by 1798 it was commonly known as Ann Street. In the middle of the century, leases had specified that building heights be at least 18 feet (5.5 m) tall and by the end of the century it contained a mix of commercial, office and residential premises.

Littlewoods is on the site of the former Artillery Barracks which, in 1798, was used to imprison captured

insurgents, including Robert Hunter and the Reverend William Steele Dickson. It was here also that Henry Joy McCracken was held following his arrest near Carrickfergus in County Antrim on 7 July 1798, with John Query and Gawen Watt. McCracken was transferred from Carrickfergus gaol on 16 July to await his trial the following day. Query and Watt were both tried on Saturday 4 August 1798 at Carrickfergus, charged with treason and rebellion and with 'being in arms with the Rebels at Antrim, on the 7th June last'. Both men pleaded guilty to the charges: Query was given life transportation, Watt received seven years' transportation.

The Linen Hall Library began in premises in Ann Street in 1788 as the Belfast Society for Promoting Knowledge and it was here that its second librarian, Thomas Russell, was arrested and sent to Dublin in 1796.

WILSON'S COURT

Cross Ann Street again and enter Wilson's Court, another narrow entry which leads to High Street.

On 4 January 1792, the *Northern Star* newspaper, the official publication of the United Irishmen's Society, was first published from premises in this entry. Its twelve proprietors, all Presbyterian businessmen, agreed to form a twenty-one-year partnership and to buy £50 shares to begin the venture. Samuel Neilson, the editor, had the largest stake of thirteen shares, totalling £650. The other shareholders were William Magee, William Tennant, Robert Caldwell, Henry Haslett, Gilbert McIlveen, William McCleery, John Robb, John Boyle, John Haslett, and Robert and William Simms.

The newspaper soon became an outspoken critic of government policy in Ireland and attracted the enmity of the administration. The main regular contributors were the Reverend Steele Dickson, the Reverend Sinclair Kelburn, Thomas Russell and, most notably, the

Reverend James Porter of Greyabbey, whose lampooning of corruption in the Ards was eventually to cost him his life.

Not surprisingly, the authorities were keen to see the end of the newspaper and an orchestrated campaign of intimidation and arrest of its proprietors was undertaken. Finally, in May 1797, the Monaghan Militia broke in and destroyed the presses, putting an end to its existence. By this stage, of the original twelve founders, only William and Robert Simms remained free, though they were to be arrested soon after.

HIGH STREET

Continue to the end of Wilson's Court, where it emerges onto High Street. Turn right and proceed along the length of High Street to St George's church.

High Street is Belfast's oldest thoroughfare and the site of the original ford across the River Farset from which the town takes its name (*béal feirste* meaning 'ford of the Farset' in Irish). Known originally as Front Street or Fore Street in the seventeenth century, it became High Street in the eighteenth. Leases in the mid-eighteenth century stipulated that buildings be at least 25 feet (7.5 m) tall, indicating High Street's importance, and by the end of the century it consisted of unbroken two- and three-storey terraces.

The Farset river, never much more than a sluggish stream, formerly flowed down the middle of the street, hence its width. It was progressively culverted and, by the 1790s, only appeared beyond Bridge Street, entering the tidal estuary of the Lagan between Chichester and George Quays where today the Albert Clock stands. Thus it would have been possible to look down the length of High Street and see a forest of ships' masts as vessels of all kinds lay moored at the bottom of the thoroughfare.

High Street was the home of the McCracken family, prior to their move to Rosemary Lane at the end of the eighteenth century.

St George's church was completed in 1810 and occupied the site of the ancient Chapel of the Ford, which was pulled down in 1774 and superseded by the grander St Anne's parish church in Donegall Street. Behind the church and to the rear of Church Lane was the old corporation graveyard where hanged insurgents were buried following their executions in 1798. However the site was low-lying and became increasingly prone to flooding at high tide, and a new graveyard was established at the rear of the poor-house (now Clifton Street cemetery).

Development at Church Lane in the mid-eighteenth century stipulated frontages of not less than 15 feet (4.5 m) in height and numbers four to ten survive today as low three-storey stuccoed terraced buildings from around 1780.

SUGARHOUSE ENTRY

Cross High Street and proceed westwards back into the town. Just past number forty-eight (River House) is a narrow alley (now closed off). This was formerly Sugarhouse Entry, which ran to Waring Street beyond.

This narrow alley contained the Franklin Inn belonging to James and Peggy Barclay, named after the American revolutionary, Benjamin Franklin. A picture of Dr Franklin hung above the door. According to some authorities the first meeting of the Society of United Irishmen took place here on 14 October 1791 and not in Crown Entry as often cited. What is certain though is that a group known as the Muddlers' Club, a front for the United Irishmen, met here regularly in the later 1790s.

Sugarhouse Entry and the surrounding area of Bridge Street, High Street and Waring Street suffered widespread destruction in the Blitz of 1941 and unfortunately little remains of the earlier period.

20 BRIDGE STREET

SHOP OF JOHN HUGHES

Continue west towards the city centre again until you reach Bridge Street. Turn right and proceed for approximately 50 m. The site of Hughes's shop is at number twenty.

On this site John Hughes, the informer, had a bookshop. Hughes had joined the United Irishmen in 1793 and became a member of the Down County Committee. He was, however, a weak man and was probably intimidated into becoming a paid informer. His collusion led to the arrest of the Reverend Steele Dickson prior to the uprising.

Other notable informers from Belfast were Edward John Newell, a miniaturist of Mill Street, and James McGuckin, a solicitor, whose offices were in Fountain Lane. Both men were United Irishmen who were in the employ of the government and responsible for the arrests of many Society members. Newell turned to alcohol and eventually confessed his actions to the Society, who promptly murdered him. McGuckin continued to supply information up to 1804 and appears never to have come under suspicion of the organisation. He died peacefully in 1817.

ASSEMBLY ROOMS

Situated at the Four Corners junction of Rosemary, North, Waring and Bridge streets, this is Belfast's oldest surviving public building though its appearance has been transformed. It was built in 1769 as a single storey 'exchange' or market house but Lord Donegall, at his own expense, commissioned the London architect Robert Taylor to add an upper floor to provide assembly rooms in 1776. It was converted by Charles Lanyon in 1845 who stuccoed the exterior and remodelled it along Italian palazzo lines. It subsequently became the Northern Bank, though behind the façade it is still substantially Taylor's two-storey five-bay building.

The Assembly Rooms gave Belfast a first-class public

assembly area and it was the venue for the famous Harp Festival of 1792. It was used as a military court during the 1798 Rebellion and it was here that Henry Joy McCracken stood trial at noon on 17 July 1798. His father, John, and sister, Mary Ann, were the only members of the family present. The Crown prosecutor, John Pollock, offered Henry Joy his life in return for information about other insurgents but McCracken refused the offer. Following his conviction he was almost immediately led off to the scaffold at the market house.

WARRING STREET

SAMUEL NEILSON'S HOUSE

From the Assembly Rooms turn eastwards along Waring (formerly Warring) Street. Sugarhouse Entry (now closed) is the first alley on the right. The site of Neilson's house is occupied by the Northern Whig Building of 1820.

Originally known as Broad Street, the street became known as Warring or Wern Street in the middle of the eighteenth century. Leases granted at this time stipulated that buildings be a minimum of 24 feet (7.25 m) high, indicating Waring Street's importance at that time.

Waring Street was the financial heart of the city, with the Assembly Rooms at the western end and Lime Kiln Dock at the eastern. The proximity of the docks meant that warehouses, shipping offices and stores predominated, with accommodation for mariners provided in Skipper Street and neighbouring alleys.

Samuel Neilson lived in one of a row of two-storey thatched cottages at the corner of Sugarhouse Entry and Waring Street. Born in 1761, he was the son of a Presbyterian minister from Ballyroney, County Down. He became a woollen merchant and his Irish Woollen Warehouse stood at the junction of Waring Street and Bridge Street. He joined the Volunteer movement and then became a member of the United Irishmen. He was also

responsible for founding the *Northern Star* newspaper, of which he was editor. Such a major figure in the United Irishmen was bound to be noticed by the authorities. He was arrested and imprisoned in 1796 and again at the beginning of 1798 when he was transferred to Fort George in Scotland. Released in 1802, he emigrated to the USA and died at Poughkeepsie, New York state, in 1803.

SHAMBLES STREET AND THE MARKET HOUSE

Return back along Bridge Street to High Street and stop at the corner of Cornmarket and High Street. This was the site of the market house outside which gallows were erected throughout the summer of 1798.

Shambles Street derived its name from the butchers' shops which occupied the thoroughfare. At the corner with High Street stood the former market house, built originally of red brick in 1639 and extended in 1663 by the addition of a first floor to provide a court-room. The building had been presented to the town by Francis Joy, an ancestor of Henry Joy McCracken. It was pulled down in 1812 to make way for shops.

At about five o'clock on the afternoon of 17 July 1798 Henry Joy McCracken was hanged from gallows outside the market house. Afterwards his body was taken down and, as a result of pleas from the family, his head was not severed as was usual. His remains were then taken to the family's home at Rosemary Lane where his sister arranged for an attempt to revive him.

Other insurgents had already been hanged at the market house: James Dickey, an attorney from Crumlin, on 26 June, John Storey, a printer from Belfast, on 30 June, Hugh Grimes on 5 July and Henry Byers on 11 July. In the case of Dickey, Storey and Byers, their heads were severed from their bodies and placed on spikes above the market. These were reported by the *Belfast News-Letter* of

17 August to have been finally removed.

Despite the seeming barbarity of the times, public hangings would soon be a thing of the past. The last to take place were those of two Belfast weavers in September 1816 who set fire to a cotton manufacturer's house in Peter's Hill following a trade dispute.

GRAND PARADE

Continue up Castle Place (formerly Grand Parade) and cross the road to Donegall Arcade.

This street, originally part of High Street, had become known as Parade or Grand Parade by the 1790s. Mid-century leases required buildings here to be of brick or stone construction and of at least 28 feet (8.5 m) in height. It therefore contained four-storey residential terraces, housing some of the town's wealthiest citizens. In later Victorian times it became the commercial centre of the town and by the 1840s was known as Castle Place.

Present-day Donegall Arcade was the site of the Donegall Arms Hotel or New Inn in the 1790s. During the Rebellion the hotel was used as a prison. It was from here that the insurgent prisoner William Kean escaped during the early hours of 2 July 1798 by climbing down a ladder placed in the rear yard. On 7 August most of those still detained at the inn were released on sureties.

Colonel James Durham, who had taken part in the Battle of Antrim on 7 June 1798, lived in lodgings in Grand Parade. On 16 July Durham was returning to the house when he was confronted by Mary Ann McCracken who had just learned of the transfer of her brother Henry Joy to the Artillery Barracks in Ann Street. She requested permission to be able to visit her brother but Durham hotly refused and proceeded to enter the house, slamming the door in her face 'with great violence'.

However, Mary Ann was to persist in her attempts to see her brother and later, when she learned that Colonel Barber (who had fought at Ballynahinch) and some other

officers were dining at the Assembly Rooms, she sent a message, requesting his permission. Barber courteously sent out one of the junior officers to accompany her to the barracks where she was able to see Henry Joy before his trial the following day.

ROSEMARY LANE

PRESBYTERIAN CHURCH

Continue through the arcade until it emerges into Rosemary Street (formerly Rosemary Lane). Directly opposite is Rosemary Street Presbyterian church, the town's oldest remaining place of worship.

In 1798 Rosemary Lane had three Presbyterian churches but today only one remains. The First Presbyterian ('New Light') church was built here between 1781–3 to the plans of the celebrated architect Roger Mulholland. The exterior was altered in 1833 to its present form, with its distinctive dark red brick. The interior is elliptical with wooden box pews and a gallery carried on Corinthian columns. John Wesley preached here in June 1789 and described it as 'the completest place of worship I have seen'.

The Second Presbyterian church (also 'New Light') was built in 1790 on ground to the rear of the first but it was pulled down in 1964 to make way for a multi-storey car-park. The congregation now worships in All Souls church on Elmwood Avenue.

The Third Presbyterian church ('Old Light') formerly occupied the site of the present Masonic Hall further east. The congregation moved to the North Circular Road to what is now known as Rosemary church.

'New Light' Presbyterians were to the fore in politics in Belfast in the latter part of the eighteenth century and many of the First congregation here were involved in the events of the period. When the Belfast Chamber of Commerce was founded in 1783, twenty-two of the 57 members belonged to the congregation. In 1785, eight of

the 12 Ballast Board members were likewise members of the congregation.

Congregation members who were also politically active included William Magee and William Tennant, founder members of the *Northern Star*. Tennant, Samuel McTier, William Drennan and Thomas McCabe were also founders of the Society of United Irishmen. Other notable members were Thomas Greg and his son, Cunningham Greg, Henry Joy Junior and Valentine Jones.

Dr William Drennan was the son of the Reverend Thomas Drennan, who was minister of the First congregation in Rosemary Lane from 1736 to his death in 1768. He was born at the manse which was located adjacent to the church and is now occupied by the Central Halls.

Two notable congregation members from opposing sides of the Rebellion have memorial tablets in the church – William Tennant and the Reverend Dr William Bruce.

WILLIAM TENNANT MEMORIAL

The memorial tablet reads:

> He employed the leisure won from an arduous mercantile career in the cultivation of science and letters. A consistent advocate of free inquiry and national liberty, he was moderate in times of popular excitement and firm when exposed to the reaction of power. Useful though unassuming among his fellow townsmen, he found his chief happiness in the affection of his family and friends.

William Tennant was born on 26 June 1759, the son of the Reverend John Tennant, Secession minister of Roseyards congregation, County Antrim. He was a highly successful businessman, a partner in the sugar-refining company of Tennant, Knox & Co. whose offices were at the junction of Sugarhouse Entry and Waring Street. At the age

of twenty-three he was one of the founder members of the Belfast Chamber of Commerce in 1783, and a supporter of the Belfast Society for Promoting Knowledge.

Tennant's interests also lay in politics. He was one of the founder members of the first Society of United Irishmen which met in Belfast on 14 October 1791 and a £50 shareholder in the *Northern Star* newspaper launched the following January. He was a committed radical and advocated the use of force when the cause of reform foundered after 1795.

On 30 November 1797 his house was the venue for a meeting at which Robert Simms was elected adjutant for Antrim. He was arrested shortly after the Rebellion collapsed on the evidence of a sworn statement by Samuel Orr, brother of the executed William Orr, which alleged his attendance at this earlier meeting along with Robert Hunter, Clotworthy Birnie and John Coulter. The charges were that these men 'did wickedly and traitorously meet, assemble, conspire, confederate, and agree together, and with other false traitors and rebels then and there present, to elect and appoint a General officer and . . . did elect and appoint a General and Commanding Officer in the rebel army . . .' All pleaded not guilty to the charges.

However, despite being brought to trial in August, the prosecution was unable to assemble sufficient evidence, as Orr was unwilling to testify, and Tennant was detained in prison, then transferred to Fort George, Scotland, in the spring of 1799. He remained there for four years before being released without trial. He returned to Belfast.

In 1809, Tennant was one of the four founders of the Belfast Commercial Bank and remained its senior partner until it merged with the Belfast Bank in 1827. With his accumulated wealth, he bought Tempo Manor in County Fermanagh in 1815. He died of cholera in Belfast during an epidemic in the town in June 1832. His remains are interred in Clifton Street cemetery but the site has been obliterated.

DR WILLIAM BRUCE MEMORIAL

Near Tennant's memorial at the front of the church is the marble memorial to the Reverend Dr William Bruce, incumbent here from 1790 to his retirement in 1831.

Born on 30 July 1757, William Bruce was the son of the Reverend Samuel Bruce of Dublin and claimed lineal descent from John de Bruce, uncle of King Robert Bruce of Scotland. He was educated at Trinity College Dublin and Glasgow University before entering the ministry. Ordained at Lisburn in 1779, he moved to Strand Street, Dublin, in 1782 and then First congregation in Rosemary Lane in 1790. He was appointed principal of Belfast Academy following the death of Dr Crombie, its founder, and remained there until 1822.

Bruce was a 'New Light' Presbyterian, but politically conservative. He and Henry Joy were to provide leadership for the more cautious elements in Belfast who were becoming alarmed at the radical activities of the United Irishmen in the 1790s. During the 1798 Rebellion, Bruce was to stand firmly behind the government by volunteering for active service with the yeomanry.

Bruce also fashioned a loyal address from the congregation to the lord lieutenant on his visit to Belfast on 25 June 1798. Although his aim was to protect the interests of the broader congregation during the turmoil following the collapse of the Rebellion, he was clearly signalling to the more radical element that their efforts had failed.

He remained a leading light in the Presbyterian community and became involved in the controversy over non-subscription in 1818 when he published his *Being and Attributes of God*, in which he expressed sympathy for Unitarian belief. Succeeded by his son as minister, he retired in 1831 and died in Dublin on 27 February 1841.

SITE OF McCRACKEN FAMILY HOME

*Continue eastwards along Rosemary Street towards Bridge Street.
On the right, immediately after number sixteen, is the entrance to
Winecellar Entry. By this corner stood the home of the McCracken
family in the 1790s.*

The McCracken family had lived previously in High
Street, opposite Bridge Street, but by 1798 were living
in Rosemary Lane. The family, headed by ship's captain
John McCracken, contained four brothers who survived
into adulthood. Francis, William and Henry Joy were all
Volunteers who later became involved in the United Irish
movement, but the youngest, John, was never drawn to
politics. Two sisters, Margaret and Mary Ann, completed
the family. The Joy and McCracken families were emi-
nent citizens of the town throughout the eighteenth cen-
tury and it was inevitable that they would be involved in
the major events of the times. On 17 July 1798, following
the execution of Henry Joy McCracken, the body was
brought to the house by his sister Mary Ann, and an
attempt made to revive the corpse. Mary Ann sent for
Dr James McDonnell, a surgeon and family friend, who
had made a special study of artificial resuscitation in his
student years. However, McDonnell did not appear and
sent his brother, also a surgeon, in his place. Despite great
efforts it proved impossible to revive the body. Later
McCracken's body was buried in the old graveyard of St
George's church in High Street, at the rear of Church
Lane.

Winecellar Entry contains White's Tavern, rebuilt as a
spirit warehouse by Valentine Jones in 1790. Jones was a
West Indian trader who later built up a flourishing wine
trade which operated from these premises. He was
involved in the Belfast Charitable Society and
contributed substantially to the funds for the erection of
the poor-house in 1774 and later to the White Linen Hall.

He was a keen Volunteer and a founder member of the
Northern Whig Club of 1790. By the 1790s he was in his
eighties and a cautious liberal. As treasurer of First

congregation in Rosemary Lane, he supervised its rebuilding in 1783. At age ninety he is said to have danced a quadrille in the Assembly Rooms with son, grandson and great-grandson, all of whom were named Valentine Jones! He died in 1804 and is buried in Clifton Street cemetery.

6 NORTH STREET

SHOP OF THOMAS McCABE

Return to the Four Corners junction of Rosemary, Bridge, Waring and North streets and turn left into North Street.

Thomas McCabe of Lisburn established a jewellery shop here in 1762. He and his son, William Putnam McCabe, became heavily involved in the United Irish movement and were well known to the authorities. In March 1793 the shop was looted by local soldiers. Afterwards Thomas had a new sign put up over the shop which read:

> Thomas McCabe, an Irish Slave
> licensed to sell Gold and Silver.

Both he and his son helped organise the Rebellion, the latter being forced to flee to France, where he died.

DONEGALL STREET

Cross North Street to the former Assembly Rooms (now the Northern Bank) and immediately turn left into Donegall Street.

Work on Donegall Street began in the 1750s but really only got under way properly in the 1780s and 1790s when Lord Donegall undertook several schemes in the area around the present St Anne's cathedral. In 1796, Martha McTier, sister of Dr William Drennan, described it as 'the bleakest street in the bleak north'. Nevertheless it contained several important buildings and linked the commercial centre of the town to the poor-house at the northern end of the street.

At the corner with Waring Street was the former school of David Manson, established here in the 1750s, which provided education for the McCracken family. David Manson's school gave children an education 'without the discipline of the rod' and was always co-educational. Manson was made a freeman of Belfast in 1779. When he died, in 1792, there was a torchlight funeral to the parish graveyard.

A few doors along, number twenty-five was built around 1790 and housed Belfast's Lying-In Hospital, which consisted of six beds and a nurse. It was established by Dr James McDonnell, formerly of the Glens of Antrim, who was an eminent surgeon and friend of the McCracken family.

St Anne's cathedral stands on the site of the former St Anne's parish church erected by Lord Donegall at his own expense in 1776 to replace the Chapel of the Ford in High Street. Donegall's church was demolished in 1900 to make way for the cathedral. The site had been the location of the original Brown Linen Hall established in the 1750s; in 1773 it moved to new premises on the other side of the street at numbers twenty to twenty-two. This site is now occupied by a five-storey red brick building with sandstone cladding on the ground floor. Brown linen was finished but unbleached material, and the trade which took place here therefore complemented that at the White Linen Hall.

On the corner of Academy Street stood the original Belfast Academy (later Belfast Royal Academy) established by Dr Crombie, minister of First congregation, Rosemary Lane. Crombie, its first principal from 1785 to 1790, obtained a ninety-nine-year lease for the school from the Donegall family in 1787 on what was then an open site on the edge of town. The school was non-denominational and consisted of three storeys, with the schoolroom on the ground floor and dormitories on the top. At this time Presbyterians were barred from Trinity

College in Dublin, and this academy was to provide them with the necessary venue for higher education.

In 1792 a famous episode took place when nine pupils, on hearing that their Easter holidays had been cancelled, barricaded themselves in the maths room until the decision was reversed. The event was for ever known as the 'barring out'.

Dr William Bruce succeeded Crombie in 1790 and continued in the post for another thirty-two years. Bruce became one of the leading advocates of the gradualist approach to reform and a fierce opponent of the United Irishmen. In June 1798 the Academy was closed and boarders sent home. Bruce sent his wife and family to Whitehaven in England and promptly enrolled in the newly formed Belfast Merchants' Infantry, known as the Black Cockades on account of their distinctive item of uniform. On 12 June, as Nugent's army left for Ballynahinch, Bruce manned the last sentry post on the Long Bridge across the River Lagan. A passing Royal Artillery officer in the column noted 'a finer soldier than Dr Bruce he did not see that day'.

THE POOR-HOUSE

Continue up Donegall Street, crossing the junction with Royal Avenue, to the junction with North Queen Street. Directly across the road are the iron gates and pathway to Clifton House, formerly the poor-house.

Clifton House is the oldest complete public building still in use for its original purposes in Belfast. The ground for the poor-house was donated by Lord Donegall but the cost of its erection was raised by public lottery funds for the Belfast Charitable Society. The building was completed in 1774 to the plans of Robert Joy.

The Belfast Charitable Society had been established in 1752 with the aim of providing accommodation for the poor inhabitants of the town. Stewart Banks, Sovereign of Belfast, laid the foundation stone on 1 August 1771 and the building took three years to complete, initially

providing ten beds for sick persons. The poor-house was closed on 9 June 1798 on orders from the military and the committee of the Charitable Society were given forty-eight hours to evacuate the premises.

The red brick building consists of a five-bay, two-storey central core with wings, all constructed over a basement storey. The pedimented façade and stone spire behind remain unaltered from 1774 despite some later extension work. Today, something of the atmosphere and ethos of the period can be conjured up by the visitor in its surrounding gardens.

CLIFTON STREET CEMETERY

INSURGENT AND OTHER GRAVES

From Clifton House, proceed up Clifton Street to the junction with Henry Place. The cemetery entrance is about 50 m along Henry Place on the left. The cemetery used to open on weekdays from 10 a.m. to 4 p.m., though serious vandalism has recently necessitated its closure and arrangements may have to be made via the Parks Department of Belfast City Council. The cemetery was not opened until about 1800 and became the municipal burying ground with the closure of the High Street graveyard. Clifton Street cemetery is divided into two parts (see p. 48); the upper area, nearest the Antrim Road, is the one which interests us.

GRAVE OF JOHN TEMPLETON

Just off the main path on the right, near the Antrim Road, is the upright sandstone marker of John Templeton, sited inside a larger gravel enclosure. The inscription reads: 'In memory of John Templeton Esq, of Orange Grove, Malone, who died on 15th Dec 1825, aged 60 years. Also of Katherine his wife, daughter of the late Robert Johnstone Esq, of Seymour Hill who died on 28th Dec 1868 aged 95 years and 9 mo.'

Originally neighbours of the McCrackens in High Street, the Templetons moved to Orange Grove, now

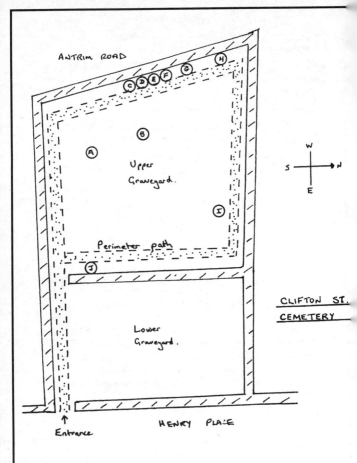

ANTRIM ROAD

Upper
Graveyard.

Perimeter path

Lower
Graveyard.

↑
Entrance

HENRY PLACE

W
S ——+—— N
E

CLIFTON ST.
CEMETERY

KEY

A. JOHN TEMPLETON
B. THOMAS McCABE
C. HENRY JOY McCRACKEN
D. MARY ANN McCRACKEN
E. HUGH RITCHIE
F. WILLIAM SINCLAIRE
G. WILLIAM DRENNAN
H. HENRY JOY
I. REV WILLIAM STEELE DICKSON
J. JOHN RITCHIE

Cranmore, in Malone. John became a highly respected botanist who established a collection of exotic trees and plants at the family home. He helped establish the school which later became the Royal Belfast Academical Institution. He was a close associate of Henry Joy McCracken's, Dr James McDonnell's and Thomas Russell's. With Russell he shared an interest in natural sciences and together they went on a walking tour of County Antrim in the early 1790s. When Russell was arrested in 1796, Templeton continued to write to him in gaol and reminded him of their former activities:

> Every walk I take in pursuit of the beauties of nature, bring to my recollection similar excursions in your company... Often does my imagination dwell with pleasure on the picturesque scenery of Glenave, and the still more sublime rocks of Rathlin. Neither can I go into my garden and view the little heathy bank you so often admired without remembering the pleasure I received from your praises of my ingenuity in forming it.

Templeton became a United Irishman in March 1797 but he was not involved in the Rebellion the following year. He terminated his friendship with Dr McDonnell following the latter's contribution of £50 to the reward fund for the arrest of their mutual friend, Thomas Russell, following his abortive 1803 rising. Templeton's sister, Eliza, brought them together again on 4 April 1825 but mixed feelings remained, as recorded in John's diary: 'Disagreeable sensations yet pass across my mind when I recollect the deed . . .'

GRAVE OF THOMAS McCABE

About 40 m north of the main path, between two minor paths, is the large, cracked, horizontal slab dedicated to the McCabe family. The inscription reads: 'Here lieth the body of Mary McCabe who departed this life April

11th 1801, aged 84 years. Also her son Thomas McCabe who departed this life March 5th 1820, aged 80 years. This tomb is erected to their memory by Isabella McCabe the disconsolate widow of Thomas McCabe.' Several other McCabes are also buried in this plot.

Thomas McCabe was a cotton manufacturer who also owned a goldsmith's shop at 6 North Street, which became renowned for its workmanship with jewellery and watches. Together with Robert Joy and Nicholas Grimshaw, he financed the installation of machinery in Clifton Street poor-house to teach children how to spin and weave cotton. In 1784 Joy, McCabe and McCracken opened the first water-powered mill in Ulster, which began a rapid era of cotton production.

In 1786 he denounced Waddell Cunningham's scheme to introduce slavery to Belfast, stating, 'May God wither the hand and consign the name to eternal infamy of the man who will sign that document', and successfully halted the proposal. McCabe became involved with the United Irishmen and his son, William Putnam McCabe, held a prominent position in the organisation. They allowed their house, Vicinage (now the site of St Malachy's College), to be used for meetings and, as a result, the house was frequently attacked by troops during March 1793.

His philanthropic interests included the Belfast Charitable Society and the Belfast Philosophical Society. A liberal and humane Presbyterian of his time, his family were to move to London in the mid-nineteenth century.

GRAVE OF HENRY JOY McCRACKEN

This grave is situated about midway along the perimeter wall adjacent to the Antrim Road. After his hanging, Henry Joy McCracken was buried in St George's parish church graveyard in High Street. When this site was closed and redeveloped his bones were re-interred in Clifton Street cemetery. The inscription on the pink granite grave surround reads: 'In this grave rest the

remains believed to be those of Henry Joy McCracken'.

McCracken is the best known of the United Irishmen in Ulster. He was born on 31 August 1767 at the family home in High Street, one of four brothers and two sisters. He is described as being about 5 feet 11 inches (180 cm) tall and very agile, 'marrying a tenderness of heart with an intrepidity of spirit'. He became involved in the flourishing cotton trade and helped establish Belfast's first Sunday School.

He became a United Irishman in 1795 though he was allegedly involved from the beginning. The organisation had, at this stage, been remodelled as a separatist, rather than a reforming, movement, with an oath of allegiance now sworn on admission. McCracken was given the task of attempting to bring the Catholic Defender movement into the broadly Presbyterian organisation, a task which by 1798 he claimed to have partly achieved. However, the seven thousand Defenders who were enrolled were noticeably absent when the Rebellion began in June, except in a modest way at Randalstown.

McCracken was imprisoned for fourteen months during 1796 and 1797. He returned to freedom, as determined as ever to carry out the plans for revolution. The date planned for the rising throughout Ireland was 23 May 1798 but passed with the Ulster leadership still procrastinating. On the resignation of Robert Simms as adjutant of Antrim, McCracken was appointed leader and sent out word that the Rebellion would begin on 7 June, the signal being the capture of the magistrates assembled at Antrim on that day.

However the call to arms was only partially heeded and the government network of spies ensured that the military were fully aware of the details of the rising. Defeat at Antrim on 7 June 1798 followed. McCracken was forced to flee, first to Slemish and then to the hills of south Antrim. While planning his exile he was recognised outside Carrickfergus in July 1798 and arrested, later being transferred to Belfast to stand trial. On 17 July he was court martialled and hanged outside the old market

house in Cornmarket.

Though unmarried, Henry Joy McCracken apparently fathered a daughter. Following McCracken's death, the Reverend Steele Dickson informed Mary Ann McCracken that her brother had a young daughter called Maria who was then about four years old. Maria's mother was probably Mary Bodel, daughter of the man who lived near Cave Hill and in whose house McCracken had hidden following the Battle of Antrim. The girl was brought up by Mary Ann. Maria married a William McCleery and died in 1878.

GRAVE OF MARY ANN McCRACKEN

In the same plot as Henry Joy McCracken's grave is a small stone block inscribed 'Dileas go h-eag [true till death]'. Mary Ann was McCracken's sister and survived him by over half a century. She was an active supporter of the United Irish movement and was romantically linked to Thomas Russell. Her tireless energy in support of her radical brothers and later her own philanthropic activities mark her out as the most important female figure of her day in Belfast.

Born in 1770, she was the youngest of the McCracken children to survive into adulthood. Educated at David Manson's school in Donegall Street, she was a lifelong friend of fellow pupil Eliza Templeton of Orange Grove.

Mary Ann was to support her brothers' political activities, first in the Volunteers and later in the United Irishmen. Following the successive arrests and imprisonment in Dublin of first Henry Joy and later of her other brothers, Francis and William, she and her elder sister Margaret were left to run the family textile interests. She also undertook the long journey to Dublin to see to her brothers' needs and attempted to resolve the bitter argument which broke out between Henry Joy and Samuel Neilson regarding early release dates (see p. 68).

After the Battle of Antrim in 1798 she searched the south Antrim hills and eventually contacted her fugitive

brother, bringing him much-needed clothes and money. She was arranging for a ship to take him to the United States when he was arrested and brought to Belfast to stand trial. Mary Ann successfully petitioned to see him in gaol and was with him during the subsequent trial and execution. Following this, she attempted to have him revived but with no success. All this she did by herself: both Francis and William were on the run, her brother John did not want to be involved in the proceedings and her father was in poor health.

Later, Mary Ann was similarly supportive of Thomas Russell prior to his execution at Downpatrick in October 1803. This was made even more difficult for her because of the romantic feelings she had for him. She was never to marry.

For the rest of her life Mary Ann was to devote herself to the relief of the needy and poor, and in particular to the work of the Belfast Charitable Society. She was to outlive all her contemporaries and, through her diaries and interviews with Dr Richard Madden in the 1850s, provide a valuable record of the events in Belfast at the end of the eighteenth century. She died in 1866 at the age of ninety-six.

GRAVE OF HUGH RITCHIE

Hugh Ritchie's grave lies 3 m to the north of McCracken's grave, and consists of a marble entablature surrounding a slate tablet within a wall enclosure. The inscription reads: 'Interred here, Hugh Ritchie, Ship Builder, who died . . . Jan 1808 aged . . . years.'

John, Hugh and William Ritchie are the trio of brothers to whom the establishment of shipbuilding in Belfast can be rightly attributed. William Ritchie was a Scot who was already building ships at his yard in Saltcoats, Ayrshire, when he was invited to Belfast by a delegation of the town's merchants in March 1791. He returned in July with ten tradesmen and some equipment, and established a shipbuilding yard at the old

Lime Kiln Dock, in partnership with his brother Hugh. The brothers launched their first ship, *Hibernian*, of 300 tons, in July 1792, 'the only vessel of any burthen which for many years had been built in the dock'.

Hugh left the firm in 1798 to establish his own company. William went on to build a dry dock capable of handling two 300-ton vessels. It still exists today, as Clarendon Dock, adjacent to the Harbour Offices in Corporation Square. From these beginnings the firm of Harland and Wolff was to emerge in the later nineteenth century, which survives to this day, the enormous cranes known as Goliath and Samson being visible from all parts of the city.

Hugh Ritchie died in January 1807 and his position was taken by his brother John. John's grave is located approximately 8 m from the upper graveyard exit along the east wall, a large white marble wall plot with an inscribed slate medallion: 'Interred here John Ritchie, Ship Builder, who died 8th April 1828 aged 77 years. Also his wife Jane Ritchie who died 26th January 1837 aged 81 years.'

GRAVE OF WILLIAM SINCLAIRE

A few metres north is a large monument of three tablets in entablature of Doric columns, secured to the west wall of the graveyard. It is inscribed: 'William Sinclaire of Belfast ob 11th Feb 1807 aged 47 years. Also Charlotte his widow died 9th Jan 1850 in her 87th year'.

William Sinclaire's political life is perhaps most representative of the changes which took place in the Presbyterian community in Belfast during the 1790s. He was to begin his political career in the ranks of the late-eighteenth-century Presbyterian radicals, but by the time of his death he had become associated with nineteenth-century Presbyterian conservatism, supporting the constitution and the union of the British and Irish parliaments as the best option for his country.

A successful entrepreneurial linen merchant, he lived

at Donegall Place, near the corner with Castle Lane. His father Thomas, who died in 1798, had been a grocer and linen merchant, and William succeeded to the family business, immediately enlarging and mechanising the bleach greens. He married Charlotte Pollock and had three daughters.

He coupled a successful commercial career with a political interest, being involved in the First Volunteer Corps of Belfast. He was an active member of the Belfast Chamber of Commerce and an early member of the Linen Hall Library. As with many other merchants in Belfast at that time, he was not satisfied with the gradualist approach to political reform of the newly formed Northern Whig Club and he helped establish the first Society of United Irishmen in 1791, befriending Thomas Russell, who had just arrived in the town.

Wolfe Tone breakfasted with Sinclaire (whom Tone nicknamed 'The Draper') on 24 October 1791 and inspected his bleach greens. Sinclaire had been the first to use imported American potash instead of barilla to bleach cotton, which had been common practice at that time. Tone was impressed and recorded in his diary, 'Almost all work done by machinery, done thirty years ago by hand, and all improvement regularly resisted by the people'.

At a meeting of the inhabitants of Belfast on 25 December 1792 in the Second Presbyterian meeting-house, which called for an equal representation of the people in parliament, Sinclaire argued that government without improved representation was no better than any other, hinting at possible unrest if reform was not forth-coming. In February 1793 he attended the Volunteer convention at Dungannon as a delegate. Here the Volunteers avowed their loyalty to the constitution but regretted the recently declared war with France and urged the reform of parliament and Catholic emancipation. The following month the Volunteers were suppressed when the government began to clamp down on all agitation.

It became clear to Sinclaire that the choice was to risk

his business and family by continuing to advocate radical reform, which increasingly threatened to lead to insurrection, or to follow a more cautionary approach. His name is missing from the later developments in the 1790s, and he must have withdrawn from his leading role in the organisation. In the edition of the *Belfast News-Letter* of 29 June 1798, his name appears amongst the list of prominent Belfast merchants, loyal but unable to serve in the yeomanry, who pledged sums of money towards its upkeep. Other former United Irishmen on the list are Gilbert McIlveen and John Sinclaire, brother of William, who lived opposite him on Donegall Place.

In October 1799, eight years after entertaining Tone, Sinclaire and his wife entertained the lord lieutenant, Cornwallis, who was on a brief visit to Belfast, by conducting him on a tour of their bleach greens. Clearly Sinclaire was conscious of the opportunities which might materialise if the union of Great Britain and Ireland were achieved and he may have been seeking economic concessions as the price of his support. Unlike Samuel Neilson, for example, Sinclaire's entrepreneurial judgement was that the Rebellion would be bad for business and might wreck what had already been achieved.

GRAVE OF DR WILLIAM DRENNAN

The badly worn, wall-mounted memorial tablet, in white marble and slate, is about 30 m further along the wall from William Sinclaire's grave.

Dr William Drennan was a physician, poet and intellectual at the outset of the formation of the United Irish movement in the 1790s. Thanks to the prolific letter-writing in which he engaged with his sister Martha McTier, and which remains largely preserved, we have an extensive knowledge of his political activities and opinions, besides much else. Best remembered today for coining the phrase 'Emerald Isle' to describe Ireland in a poem, he was in fact the originator of the idea of the Society of United Irishmen and deserves to be more widely

recognised for his contribution to the politics of the day.

He was born in Belfast on 23 May 1754, the son of the Reverend Thomas Drennan, Presbyterian minister of First congregation in Rosemary Lane and close friend of the philosopher Francis Hutcheson. The young William gained an MA at Glasgow University in 1771 and obtained his MD from Edinburgh in 1778. Returning to Ireland, he began his practice as an obstetrician in Newry, later moving to Dublin in 1790. Clearly ahead of his times, he advocated inoculation as a method of preventing smallpox in the 1780s and in 1793 recommended the practice of washing the hands to prevent the spread of infection.

His genius was not confined to his professional activities and on arrival in Dublin he quickly involved himself in politics, being an admirer of parliamentarian Henry Grattan. However Drennan was a radical Presbyterian in the tradition of the American revolutionaries of the 1770s and, with the outbreak of the revolution in France, he initially supported its promise of greater democracy for the common people. He rejected the Whig clubs as frail vehicles for reform. Instead he proposed a plan for a secret society (to his brother-in-law Samuel McTier, in May 1791) which would champion the cause of reform by demanding universal suffrage and proper representation in parliament. This would, by its nature, include Catholic emancipation.

By adopting a test of membership and various symbols and ceremonials along the lines of the Masonic Order, Drennan hoped to achieve an aura of secrecy which would stimulate the interest of outsiders keen to share in the vision. It was to be a 'benevolent conspiracy – a plot for the people', but it was a constitutional movement and was to remain so until forced underground in 1795.

Drennan also proposed a test of membership which he had adopted for the organisation at the second meeting of the first Dublin society, in which he held office in the committee. The test read:

> I . . . in the presence of God do pledge myself to my
> country that I will use all my abilities and influ-
> ence in the attainment of an impartial and ade-
> quate representation of the Irish nation in Par-
> liament; and as a means of absolute and immediate
> necessity in the establishment of this chief good to
> Ireland, I will endeavour, as much as lies in my
> ability, to forward a brotherhood of affection, an
> identity of interests, a communion of rights and a
> union of power among Irishmen of all religious
> persuasions, without which every reform in Par-
> liament must be partial, not national, inadequate
> to the wants, delusive to the wishes and insuffici-
> ent for the freedom and happiness of this country.

Wolfe Tone and Thomas Russell objected to his test at
this meeting and were to challenge Drennan for the intel-
lectual leadership of the movement.

In 1792 Drennan produced his *Address to the Volunteers of
Ireland* which was taken up and published by the *Northern
Star*. Though it talked of taking up arms and denounced
the government as unrepresentative, it was constitutional
and loyal in its demands for reform. However Drennan
and the newspaper's owners were to stand trial in May
1794 for printing seditious libel. Drennan was eventually
acquitted but the shock of the trial unnerved him and
proved to be the turning point of his radical career.

He became increasingly gradualist and cautionary in
his pleas for reform. In his letters to his sister he com-
plained of being left in the dark by Neilson, Russell and
Simms. In January 1795 he urged support to resist France
though he remained anti-aristocratic, and by 1797 his
association with the United Irishmen had become
strained: 'Is it not curious, my dear Matty, that I, who
was one of the patriarchs of the present popular societies,
should be at present civilly shoved out of their company?'

Drennan was to take no part in the Rebellion of
1798 and survived unmolested. In 1800 he married
Sarah Swanwick and they had four sons and a

daughter. He remained a liberal and devoted himself to medicine and poetry.

GRAVE OF HENRY JOY

A tablet secured to the west wall in a badly decaying, high-railed, low stone enclosure, is inscribed: 'Henry Joy, son of Robert Joy and Grace Rainey, 1754 to 1835, and to his wife, Mary Isabella Holmes, 1771–1832, and his family.'

Henry Joy was the son of Robert Joy and cousin of Henry Joy McCracken. To distinguish him from his uncle and a cousin of the same name, he was known as Henry Joy Jr. One of the most distinguished liberals of his generation, he was an able secretary rather than a leader of men and it is perhaps unfortunate that he was unable to provide the moderate reform faction with the leader they so clearly lacked during the critical period of the late 1790s.

The Joys were one of the pre-eminent Presbyterian families in Belfast in the eighteenth century. Henry's grandfather, Francis Joy, had founded the *Belfast News-Letter* in 1737 in Bridge Street, the oldest newspaper in continuous publication in Ireland. He trained in the newspaper's office under his uncle, Henry Joy, on whose death he assumed sole responsibility for the newspaper. His father and uncle owned a paper mill in Cromac, helped establish the Belfast Chamber of Commerce and contributed to the building of the White Linen Hall in 1783. Henry Joy inherited the family wealth and Whiggish liberal traditions.

A keen Volunteer, he was secretary in the 1783 committee which urged for parliamentary reform in the wake of the newly won constitution. In 1783 he represented Belfast at the national convention in Dublin which called for a 'more equal representation of the Commons of Ireland'. He joined the Northern Whig Club at its inauguration in 1790, becoming its secretary, and helped in their planning to celebrate the Fall of the Bastille in July

1791. When Wolfe Tone published his pamphlet *An Argument on Behalf of the Catholics of Ireland*, he was invited north to address the club in October 1791 but, in a heated debate, Tone found himself at odds with Joy's cautionary approach. The split between moderates and radicals became apparent at a meeting of Belfast citizens at the beginning of 1792: Joy and other gradualists agreed to agitate for all the Penal Laws to be annulled but required guarantees before accepting Catholic emancipation outright.

With the *Northern Star* now vying for readership in direct competition with his own paper, he began to publish a series of articles in the *Belfast News-Letter* titled 'Thoughts on the British constitution'. In these articles he argued strongly for the maintenance of the present constitutional arrangement while acknowledging the need for reform. However, his position was undermined when government 'proclaimed' the Volunteers in March 1793 following Britain's declaration of war with France. The government had clearly demonstrated its unwillingness to tolerate further dissension and the political lead passed from the moderates to the hard liners.

GRAVE OF THE REVEREND WILLIAM STEELE DICKSON

Dickson's grave is about 60 m from Drennan's, along the gravel path at the rear of houses nearby in Pim Street. A badly flaking, upright sandstone tablet is inscribed 'Patriot Preacher Historian, Do Cum onora na h-Ereann [for the honour of Ireland]'.

William Steele Dickson was born in 1744, the eldest son of John Dickson of Ballycraigy near Mallusk. He studied at Glasgow University and chose the ministry after showing an initial interest in law. In 1771 he became minister for Ballyhalbert congregation in County Down before moving on to Portaferry in 1780. He married Isabella McMinn and they had six children.

Dickson was a supporter of the American revolutionaries and became a Volunteer in 1778, representing the

Ards area at the Dungannon Convention of 1793. He worked tirelessly to help the Whig candidate Robert Stewart (later Lord Castlereagh) get elected to parliament. He was an advocate of Catholic emancipation and when the Society of United Irishmen was founded in 1791 he quickly became a member, although he stated – incorrectly – that he never actually attended meetings. In 1793 he was elected moderator of the Synod of Ulster, the highest position for a Presbyterian minister.

His very public opinions attracted the notice of the authorities and he was closely watched. His frequent visits around the countryside also aroused suspicion and when he set out for Dublin on Christmas Day 1796, during the Bantry Bay scare, Castlereagh had him followed. When Thomas Russell was arrested in 1796, Dickson was appointed adjutant general of the County Down forces, though he himself never admitted it. During his travels in the north Down area, he was arrested near Ballynahinch and confined at Blaris on 5 June 1798. As a carriage was refused him, he walked the 13 km (8 miles) from Ballynahinch in the hot sun, only arriving late in the evening. From Blaris he was transferred to the Artillery Barracks in Belfast where he shared a cramped cell with four others.

Despite attempts to obtain evidence to have Dickson indicted, a willing informer could not be found and he was to spend the next ten months in gaol, seeing out the Rebellion and its aftermath in confinement. Even then he was still too dangerous a figure to release and in 1799 he was transferred with Samuel Neilson, Robert Simms and several others to the prison at Fort George, Scotland. He was not finally released until 1802.

On his return he accepted a calling to Keady congregation. In 1812 he published his memoirs in which he criticised his treatment by fellow clergy, particularly the synod, which had refused him the Regium Donum – the annual stipend given to Presbyterian ministers by the state and administered by synod – on his appointment at Keady. From 1815 his health deteriorated and he was

looked after by friends, amongst whom were William Drennan, William Tennant and Francis McCracken. He died penniless; his funeral was attended by only eight people and he was buried in a pauper's grave here, the headstone only being erected in 1909.

CHAPEL LANE

ST MARY'S CATHOLIC CHAPEL

Return back along Upper Library Street, turn left into Castle Street and then left into Chapel Lane. St Mary's chapel is approximately 100 m on the left.

This street, originally known as Crooked Lane, was the site of the first Catholic church in Belfast. It was erected with a sizeable contribution from the Presbyterians of the town and opened with a procession of Belfast Volunteers led by their captain, Waddell Cunningham, on 30 May 1784. Previously, on 13 May, Cunningham had invited persons of every persuasion into the ranks of the first Volunteer company, a move copied shortly afterwards by William Brown, captain of the Belfast Volunteer Company.

The church seen here today is said to contain some of the walls of the original chapel.

CUNNINGHAM'S ROW

KELLY'S CELLARS PUBLIC HOUSE

From St Mary's chapel proceed east into Bank Street (formerly Cunningham's Row). Kelly's Cellars is on the right hand side, approximately halfway down the street.

Cunningham's Row was named after Waddell Cunningham, whose house stood near the entrance to Castle Place. It was described as a 'commodious but not imposing mansion' but was attacked and burned by the

Hearts of Steel mob in 1770. The Hearts of Steel was a mainly Presbyterian, agrarian organisation, opposed to the raising of rents, particularly on Lord Donegall's estates in County Antrim. Cunningham was a land agent for Donegall.

Bank Street also contains Kelly's Cellars which is Belfast's oldest surviving public house. Built in approximately 1780, it is a two-storey building with an irregular façade. It has close associations with the United Irishmen, who are reputed to have plotted their Rebellion here. One story recounts that Henry Joy McCracken hid under the bar to escape the military who were attempting to arrest him. It is the ideal place to end this journey and quench one's thirst after a busy day's walking!

GREATER BELFAST

ANTRIM ROAD A6

M2 MOTORWAY

A52 CRUMLIN ROAD

WESTLINK

HOLYWOOD

NEWTOWNARDS ROAD A20

CASTLEREAGH ROAD

M1 MOTORWAY

LISBURN ROAD

BALLYGOWAN ROAD A23

SAINTFIELD ROAD A7

UPPER MALONE ROAD B103

SHAW'S BRIDGE

RIVER LAGAN

B205

KEY

1. Castlereagh Presby. Church
2. Knockbreda Parish Church
3. Drumbeg Parish Church
4. Ulster Museum
5. McArt's Fort

0 1 2 Kms

GREATER BELFAST

This tour takes in sites on the periphery of Belfast and transport is required to travel between them. It begins in Castlereagh and proceeds around the southern fringe of the city to finish at Cave Hill in the north. It includes the graves of many of the most important figures from the late eighteenth century, and the 1798 Rebellion in particular.

CASTLEREAGH PRESBYTERIAN CHURCH

GRAVE OF THE REVEREND SINCLAIR KELBURN

OS Sheet 15, 374708
From the centre of Belfast take the A29 to Ballygowan via the Castlereagh Road. Beyond the junction with the Outer Ring dual carriageway, the road rises steeply. About 0.5 km (0.3 miles) up on the right, take the turning to Church Road. The large white church, in the style of a Greek temple, soon appears on the right. Kelburn's grave is 12 m in through the pillars of the old part of the cemetery, a raised horizontal slab with the lettering well worn.

The Reverend Sinclair Kelburn was born in 1754, the son of a Dublin minister. Educated at Trinity College Dublin, he became minister for the Third Presbyterian church in Belfast in 1780. Although buried here, Castlereagh was never his church at any time.

Kelburn became involved with the Volunteer movement and then the Society of United Irishmen. He wrote articles in the *Northern Star* and attacked the injustices of government at every opportunity. Following the damage caused to Peggy Barclay's public house in Belfast by soldiers in 1793, he is said to have taken to his pulpit the following Sunday in the uniform of a Volunteer and preached against this outrage.

He was arrested in 1797 and spent some time in gaol. He was the minister who attended McCracken in the Artillery Barracks in Belfast prior to the latter's hanging in July 1798. The confinement in gaol ruined Kelburn's health. He was finally released in 1799 but died soon after. The headstone reads: 'Here rests in hope of a resurrection to eternal life all that is earthly of the late Reverend Sinclair Kelburn, who for 22 years with much propriety and utility sustained the character of Dissenting Minister of the 3rd Congregation of Belfast. Obit, 31st March 1802, aged 48 years.'

KNOCKBREDA PARISH CHURCH

OS Sheet 15, 351701
From Castlereagh Presbyterian church, turn right and continue to the end of Church Road. At this junction, turn right onto Manse Road and after one kilometre (0.75 miles) turn right onto Glencregagh Road until it descends to the junction with the Outer Ring dual carriageway. Cross the Outer Ring and, shortly afterwards, cross the Saintfield Road onto (another) Church Road. Knockbreda church is on the left at the top of the hill.

Knockbreda parish church was built in 1737 for the dowager Viscountess Middleton, reputedly to the plans of the architect Richard Cassels who designed Powerscourt, County Wicklow, and Westport House, County Mayo. Set on a hillside, the church offers superb panoramic views north over the city.

GRAVE OF HENRY HASLETT

Walk up the steps to the front doors of the church. The grave of Henry Haslett is 10 m to the left (north). A white upright marble slab inside a dressed sandstone surround carries the inscription: 'To the memory of Henry Haslett of Belfast, merchant, who departed this life 4th December 1806, aged 48 . . .'

Henry Haslett, a Presbyterian ship-broker, was one of the original members of the first Society of United Irishmen which met in a building off High Street, Belfast,

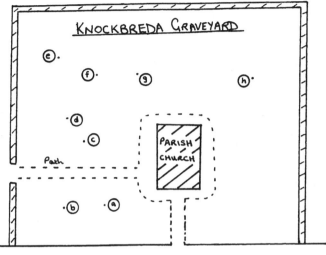

KNOCKBREDA GRAVEYARD

PARISH CHURCH

Path

CHURCH ROAD

KEY

a. HENRY HASLETT
b. REVEREND ROBERT ACHESON
c. WILLIAM SIMMS
d. WADDELL CUNNINGHAM
e. THOMAS & CUNNINGHAM GREG
f. SAMUEL NEILSON'S FAMILY
g. JOHN BROWN
h. CORTLANDT SKINNER

on 14 October 1791. He was also one of the twelve businessmen who established the *Northern Star* newspaper in January 1792 to promote the ideas and arguments of the United Irishmen. As a captain in the First Belfast Regiment of Volunteers he paraded with his regiment to the Second Presbyterian church in Rosemary Lane

on Sunday 3 February 1793. When government outlawed assemblies and hence future Volunteer parades, at the beginning of March that year, he acted as secretary in the Volunteer Standing Committee of County Antrim which met in Ballymena on 19 March 1793. This committee declared its loyalty to the laws of the land, vowing that Volunteers had assembled only for constitutional purposes. However, the government was intent on clamping down on dissension and Haslett was viewed as an agitator. In May 1794 the *Northern Star* owners were committed to trial for printing libellous sedition, although later acquitted.

As part of the pre-emptive measures to thwart an expected uprising following the 1796 harvest, Haslett was arrested in September and remained at Newgate and later Kilmainham gaols in Dublin with Samuel Neilson, amongst others. During his confinement he had a difference of opinion with Henry Joy McCracken, who had also been arrested at the same time. The prisoners had originally agreed when arrested that none should go free until all were freed together. However they were unable to prevent their families from attempting to obtain their release and Haslett's family, together with Neilson's and Charles Teeling's, were accused by McCracken of breaking their original agreement. In a letter to his sister, Mary Ann, in August 1797, Henry Joy McCracken described Haslett as 'one in whom selfishness was always visible'. The argument was patched up but must have soured relations with McCracken. Ironically both he and McCracken were released in December 1797, whilst Neilson was to remain incarcerated.

In February 1798, an anonymous letter from Newtownbreda to the government's chief secretary described Haslett thus: '[He] is an active United Irishman — was confined in Kilmainham but got out. He and his party have been the means of seducing Newell and Bird [government informers] from your employ.' Despite this reputation, Haslett appears to have gone back to his former business and was not consequently

involved in the uprising. In the edition of the *Belfast News-Letter* of Monday 5 June 1798, a shipping advertisement placed by Haslett as agent for the *Catherine* appears amongst columns containing information regarding the Rebellion in Ulster and elsewhere. With personal and financial ruin close at hand, he may have believed, on his release, that he had sacrificed enough and decided to concentrate on matters closer to home.

The grave also contains the remains of two children, one of whom died during Haslett's period of incarceration, and of his sister Margaret, who died in Dublin, perhaps on a visit to see her brother.

GRAVE OF THE REVEREND ROBERT ACHESON

From Haslett's grave, continue north for 8 m to a large, slightly raised horizontal slab.

Robert Acheson, a native of Clough, County Antrim, completed medical studies at Edinburgh University and practised for a while at Coleraine before entering the church. Licensed at Templepatrick, he came to Glenarm in July 1792 as assistant to the Reverend Thomas Reid, his elderly uncle. He was a 'New Light' minister in an orthodox congregation and consequently found it difficult to get established there.

A United Irishman, he is reported to have drilled troops in the fields behind Glenarm. Early on 7 June 1798, as a pre-emptive measure, he was arrested by the military garrison at Glenarm who then occupied the castle in the village. The United Irishmen retaliated by assembling at Bellair Hill, a mile (1.5 km) to the west, and captured several prominent yeomen and loyalists. Edward Jones Agnew negotiated an exchange of prisoners, including Acheson, William Coulter and Hugh McCoy of Glenarm (see pp. 97–8). On his release, Acheson immediately donned his uniform and joined the rebel camp as their commander-in-chief. Early the following morning, Agnew visited the camp and saw Acheson 'in full regimentals, green jacket faced with yellow, white

breeches, black hose and silver buckled shoes'.

By that evening, news of the defeat at Antrim had been widely circulated on the hill and Agnew convinced Acheson of the futility of any further open rebellion. Following negotiations with Captain George Stewart of the Glenarm Yeomanry, Acheson advised the insurgents to surrender their arms with sureties. The following morning nothing was left of the insurgent assembly. Acheson was arrested and stood trial before a court martial on 25 July along with Pat Magill, Alexander Stewart and Thomas McIlhinch. Each was charged with 'traitorously assembling with a body of rebels at the Glyns on 7 and 8 ult and being in arms'. Acheson was further charged with being the leader of the insurgents. As the trial progressed, McIlhinch pleaded guilty but Acheson and the others were eventually acquitted on Saturday 28 July. It is believed the leniency of Colonel Leslie of the Monaghan Militia and the influence of Acheson's minister uncle were important factors in the verdict.

He was transferred to Donegall Street church in Belfast in 1799 and remained there until his death on 21 February 1824.

FAMILY GRAVE OF WILLIAM SIMMS

Proceed 10 m north from the north side of the church. Situated very close to a yew tree is a tall upright stone marker of the Simms family of Grove, Belfast. It reads: 'This is the burying ground of William Simms of Belfast where lies interred three of his children, two of them named Eliza who died in infancy in the years 1792 and 1795 . . .'

William Simms and his brother, Robert, were linen merchants in Belfast and together owned a paper mill at Ballyclare, County Antrim. William was the secretary in the first Society of United Irishmen which met in a house off Crown Entry in October 1791. He was also a founder of the *Northern Star* newspaper and involved in the libel case of May 1794.

Simms was present at the meeting at McArt's Fort on the Cave Hill above Belfast in June 1795 when Wolfe Tone, Samuel Neilson, Henry Joy McCracken, Robert Simms, Thomas Russell and others vowed, according to Tone, not to desist until independence had been achieved. William was arrested on 3 February 1797, along with his brother, and spent four months in gaol before being released on bail.

In 1799 he was described by an informant as being 'closely connected with Tennant, Russel, Sampson, Neilson and the whole Executive of this town, when they were formed, is proprietor of the Paper-Mill at Ballyclare ... and is firmly believed to be much more really implicated than the man in Fort George [his brother Robert] ... being much more artful and cunning'.

Simms died on 2 August 1845 aged eighty years. His wife, Eliza, and a fourth child, Anne Jane, are also interred here. The gravestone reads: 'Blessed are the dead who die in the Lord'.

WADDELL CUNNINGHAM MONUMENT

The massive, ornate mausoleum to Waddell Cunningham lies 6 m east of Simms's grave. Cunningham was another wealthy merchant who traded in West Indian goods. The connection prompted his proposal in 1786 to form a Belfast slave ship company. The scheme was bitterly denounced by many in the town and was not pursued.

He was one of the original Belfast Volunteers and a founder member of the Northern Whig Club of 1790. Despite these liberal credentials, he fell foul of many of the radicals. During the Hearts of Steel unrest in the 1770s, he was responsible for the arrest of David Douglas of Templepatrick, County Antrim, who was then held in barracks in Belfast. A large crowd of Douglas's neighbours marched via Skegoneill Avenue and burned Cunningham's home on the way before attempting to

release Douglas by force from the barracks. As captain of the first Belfast Volunteer Company, he presented his troops as a guard of honour at the opening of Belfast's first Catholic chapel, St Mary's in Chapel Lane, on 30 May 1784. In October 1791 he met Wolfe Tone in the Northern Whig Club and in a debate that ensued he sided with Henry Joy, Dr Bruce and the other gradualists.

GRAVE OF THE GREG FAMLY

Several metres north-east of Cunningham's grave is a similar mausoleum with urns, festoons and coupled Doric columns at the corners. This is the monument to Thomas Greg and is inscribed: 'Erected to the memory of Thomas Greg Esqr of Belfast who departed this life 10th day of January in the year of our Lord 1796 aged 75 years ... Also Cunningham Greg of Ballymenock Esqr, youngest son of Thomas Greg who departed this life 8th April 1830 aged 68 years'.

Yet another of the wealthy merchants of the town, Greg was responsible for improvements to the docks at the lower end of High Street. In a 1767 lease, he was required to build two or more good-sized houses facing the town dock and a substantial stone-built quay with a drawbridge at one end, strong enough to carry loaded waggons.

His son, Cunningham Greg, is the merchant whom General Lake believed was responsible for the Monaghan Militia having become infiltrated by the United Irish organisation in May 1797. Despite his suspicions, Lake was unable to prove the link and Greg remained unmolested.

GRAVE OF THE NEILSON FAMILY

Five metres south-west of the Greg mausoleum is the recumbent headstone of Samuel Neilson.

> 1793
> This is the burying place of Samuel Neilson where lies interred one of his children named

Alexander who died in infancy. And the remains of 2 still-born female children 19th April 1794. Here also is deposited the body of Anne Neilson, relict of the above Samuel Neilson who died in exile, and mother of these children. A woman who was an ornament to her sex, who fulfilled in the most exemplary manner and under the severest trials the duties of a daughter, wife and mother. Her distinguished worth and virtues eminently qualified her to adorn society and her tender maternal affection will ever be preserved in the memory of her children. She died 2nd November 1811 aged 48 years ...

Samuel Neilson is arguably the most influential Ulster figure associated with the cause of the United Irishmen, from its inception to the conclusion of the ill-fated Rebellion and subsequent union with Britain. His story illustrates the absolute commitment of a man to his vision of a better society.

Born on 17 September 1761 in Ballyroney, near Rathfriland, County Down, he was the third son of the Reverend Alexander Neilson, minister of the local Presbyterian church. He was described as 'bold, manly, generous and persevering', and contemporaries fondly remembered him as a natural leader. He was apprenticed to his brother John, a woollen draper in Belfast, and from there he quickly acquired his own extensive woollen business, the Irish Woollen Warehouse, located on the site of the present *Northern Whig* premises in Bridge Street. In 1785 he married Anne Bryson, daughter of the wealthy William Bryson. With his wife's inheritance and his own business interests he was one of Belfast's richest young men in the early 1790s.

As with many of his contemporaries, Neilson coupled his commercial success with a passionate interest in the politics of the time. In the 1790 general election he supported the Northern Whig Club member, Robert

Stewart (later Lord Castlereagh) for one of the two County Down seats in parliament. Stewart was successful in his bid but quickly proved a disappointment to the more radical reformers who had hoped he would represent their views in Dublin. Moreover the reforms outlined by the Northern Whig Club were insufficient to Neilson and as a result he helped establish the first Society of United Irishmen in 1791.

He was also instrumental in the establishment of the *Northern Star* newspaper as the voice of the movement, in January 1792. He was the paper's editor and in time became the sole proprietor. After 1794, when the *Northern Star* was accused of printing seditious libel, weaker wills stood back from active politics, but Neilson was determined to carry the movement forward.

In May 1795, realising that any hope of reform could not succeed without force, he took the famous oath on Cave Hill with other prominent United Irishmen to 'never desist until Ireland was free'. The organisation now went underground to plot the Rebellion and Neilson played a key role in co-ordinating the revolt nation-wide. However, the authorities were aware of his role, and he was arrested in September 1796 and confined in Kilmainham gaol. Whilst there he became embroiled in an argument with Henry Joy McCracken over his family's attempts to obtain his early release (see p. 68). Ironically, he was to remain incarcerated until February 1798, three months after McCracken's release, and was only freed on condition that he refrained from further contact with the United Irishmen. William Bird, the informer, was to give evidence against Neilson, but Bird fled to the US in late 1797 and the Crown case against Neilson collapsed.

By now his health had deteriorated and he was a heavy drinker. The wealth he had accumulated had been eaten up by his political activities and by his absence from the business. Nonetheless, he was still determined to continue the plan to stage a rebellion. In March 1798 the Leinster leadership was arrested at Oliver Bond's house in Dublin and Neilson found himself, together with

Lord Edward Fitzgerald, the two Sheares brothers from Cork and William Magan, as the only national executive members remaining at large. When Fitzgerald was arrested on the eve of the uprising Neilson, in a drunken condition, planned to spring him from his cell at Newgate, but he was recognised wandering around outside and was himself arrested. When the Rebellion failed, the government offered the leaders their release in return for information regarding the nature and extent of the Rebellion. Neilson's evidence, submitted on 9 August 1798, stated: 'The original object was solely that contained in the test – namely equality of representation without distinction on account of religion; The ideas of a republic and separation grew out of the severities practised by Government upon the people.'

Despite this agreement he was transferred, in March 1799, to Fort George in Scotland where he remained until his eventual release on 31 June 1802. As part of the condition of this release he was obliged to exile himself and duly emigrated to the USA. Despite plans to start a new career, his health continued to deteriorate and he died at Poughkeepsie on 29 August 1803. His continuing commitment to Irish independence is evident in a letter to Archibald Rowan Hamilton:

> Neither the eight years hardship I have endured – the total destruction of my property – the forlorn state of my wife and children – the momentary failure of our national exertions – nor the still more distressing usurpation in France – have abated my ardour in the cause of my country and of general liberty. You and I, my dear friend, will pass away but truth will remain.

The grave here does not therefore contain Neilson's remains. The loss of three children at the height of his political involvement highlights the personal and private cost which he suffered.

GRAVE OF JOHN BROWN

Nine metres south of the Neilson family's grave is a large pedimented wall memorial to the Lyons family, which also contains the remains of John Brown and his wife Anne:

> Beneath this marble are deposited the remains of John Brown Esq, of Petershill in the town of Belfast. He supported through life a character strongly marked by integrity, honour, and diffidence. Warmly attached to the constitution of his country from his youth, he was a steady supporter and watchful guardian of her interests at the most critical periods of time. He served the office of High Sheriff of Co Antrim in 1783, and filled the arduous appointment of Sovereign of Belfast, his native town for many years, with lasting advantage to the public good. He died Novr 11th 1801 at Belfast in his 51st year, leaving no personal enemies but those of honour, honesty and the constitution . . .

John Brown was a linen draper, housing developer and several times Sovereign of the town of Belfast. He was a prominent Volunteer and Freemason and was active in raising four yeomanry corps in Belfast at the time of the threatened French invasion in 1796, becoming a captain in one of these.

He was in England when the 1798 Rebellion broke out, and immediately attempted to get home. His boat, the *Linen Hall*, was boarded by insurgents off Donaghadee and he and his wife were identified and brought ashore as prisoners. Circumstances prevented his being transferred to a mock trial at Ballynahinch and as news of Monro's defeat reached Donaghadee, his captors melted away. He took a rowing boat and, together with his wife and an old man, set off for Belfast Lough where they were picked up by a naval frigate and transferred to Belfast. On his arrival there, on 14 June, he joined his yeomanry unit.

On 25 June he was again elected Sovereign of Belfast, assuming responsibilities from the Reverend William Bristow later in the year.

GRAVE OF CORTLANDT MACGREGOR SKINNER

From Brown's grave walk 25 m south to the upright headstone of Cortlandt Skinner, approximately 20 m south-east of the church. It consists of a dressed, upright sandstone frame and is flanked by other Skinner stones with small markers set horizontally below:

> Beneath this stone are deposited the remains of Mrs Skinner, wife of the late General Skinner who departed this life Jan 4th 1810 aged 78 years. Here resteth the remains of Cortlandt Macgregor Skinner Esq formerly Captain in the 70th Regiment. He afterwards commanded the celebrated troop of Belfast Cavalry whose activities during the eventful year of 1798 was so serviceable to the country. He held the commission of peace for the Counties of Down and Antrim for 16 years. Truely benevolent he lived respected by all and in him the poor and afflicted found a friend, for charity marked his work through life. He died 30th January 1842 in his 76th year. Sacred to the memory of Isabella his beloved wife who died on 10th Feb 1846 in her 80th year.

Cortlandt Macgregor Skinner, of Dutch-Scottish ancestry, was the son of General Cortlandt Skinner, the former attorney-general of New Jersey. During the American War of Independence, General Skinner had raised a corps of loyalist volunteers known as 'Skinner's Greens', in which he held the rank of brigadier-general. As a result, he and his family were forced to leave America in 1776, moving first to Jamaica and later to Britain.

His son, Cortlandt Macgregor Skinner, was also a soldier, having held the rank of captain in the 70th

Regiment before settling in Ulster. According to the inscription he was a Justice of the Peace for counties Antrim and Down for sixteen years and commanded one of the troops of the Belfast Yeomanry Cavalry. He rode with his troops through the devastated town of Ballynahinch a few days after the battle there and was appalled at the anarchy still prevalent. He immediately established a police force of twelve of the town's most respected citizens, which brought an end to the chaos.

As a magistrate he was actively engaged in obtaining pledges of loyalty from the citizens of various towns and villages throughout Antrim and Down, with mixed results: on 29 May he obtained the signatures of three hundred of the principal landowners of Islandmagee pledging support for the maintenance of the constitution, but nine days later the peninsula was in open revolt. Skinner was also to serve on the jury which convicted Thomas Russell at Downpatrick in October 1803 (see p. 160).

In November 1797 Skinner's sister, Maria, married General George Nugent, the victor of Ballynahinch, which made him brother-in-law to the officer commanding all troops in the north of Ireland. His memorial here also records his charitable works. His wife, Isabella, and mother are also buried here.

DRUMBEG PARISH CHURCH

GRAVE OF WILLIAM GOULDIE

OS Sheet 15, 307669
Return to the Saintfield Road, turning right onto the Outer Ring road (Newtownbreda Road), and continue past Shaw's Bridge to the Upper Malone Road junction. Turn left here and continue for approximately 3 km (2 miles) to Drumbeg parish church on the left.

The present building dates from 1860, but the tower is from an earlier church and has the date 1798 on a plaque.

At the rear of the church a gravel path runs through the graveyard. Proceed along this path for 25 m then turn off to the left and continue for 15 m. Near the south boundary wall is the small Celtic cross memorial to William Gouldie, inscribed, 'In memory of William Gouldie, an Irish Volunteer of 98, died April 8th 1873 aged 104 yrs'. Gouldie must surely have been the last survivor of the ill-fated 1798 Rebellion.

ULSTER MUSEUM

1798 REBELLION ARTEFACTS

OS Sheet 15, 336724
Return along the Upper Malone Road to the Outer Ring road junction. Take the Malone Road exit, heading for Belfast city centre. Turn right onto the Stranmillis Road after approximately 0.75 km (0.5 miles). The Ulster Museum (signposted) is situated at the bottom of the road on the right, in the Botanic Gardens.

The Ulster Museum houses a significant collection of artefacts from the late eighteenth century, and from the 1798 Rebellion in particular. These include the following: Henry Joy McCracken's uniform, allegedly worn at the Battle of Antrim on 7 June 1798, and a second green coat, faced with yellow, which was worn by him as a member of the Belfast Volunteers; a frock coat belonging to Dr William Drennan; James Hope's death mask and portrait; two examples of a pike, 4 m long, the favoured weapon of the insurgents; militia cross-belt plates from five of Ulster's county units; the coat of the Londonderry Militia Grenadier Company; yeomanry regalia from numerous units; the side drum of the Belfast Yeomanry Infantry; a guidon of the Colerain (sic) Infantry; and muskets and small-arms of the period.

In addition to the above, the museum has some interesting permanent displays which explain the background to the period.

McART'S FORT ON CAVE HILL

SOLEMN PLEDGE OF 1795

OS Sheet 15, 323796
From the museum, proceed into Belfast city centre and take the
Antrim Road from Carlisle Circus. Follow this road north for
about 3 km (2 miles) to the signpost for Belfast Castle. Park near
the castle and walk up through the wooded hillside for about
0.75 km (0.5 miles) until you reach McArt's Fort and the caves.

One of the most famous places associated with the United Irishmen, McArt's Fort is an earthwork and prominent landmark on the summit of Cave Hill. It was here in the summer of 1795 that Henry Joy McCracken, Robert Simms, Thomas Russell, Samuel Neilson, William Putnam McCabe, Theobald Wolfe Tone, and perhaps a few others, climbed the hill to take in the magnificent panoramic views and to make a pledge to bring about the complete separation of Ireland from Britain, or to die in the attempt. Three years later, the fortunes of each had changed beyond recognition, the Rebellion had collapsed in defeat and the authorities were closing in.

If for no other reason, the climb is worth it for the superb views over Belfast and beyond into County Down.

EAST AND NORTH ANTRIM

This tour begins at Ballyeaston, near Ballyclare, where the decision to start the Rebellion was taken, and makes its way via Carrickfergus and Islandmageee to Larne, site of the first skirmish in the early hours of 7 June 1798. It then proceeds north along the coast road before finishing in Ballymoney.

BALLYEASTON

SECOND PRESBYTERIAN CHURCH

OS Sheet 15, 286933
From Belfast take the A8(M) for Larne. At Ballyclare take the road for Ballyeaston – about 4 km (3 miles). At the top of the village, on the Trenchhill Road, is the Second Presbyterian church.

The church dates from 1787 and was erected during the ministry of the Reverend William Holmes. An engraved stone listing the ministers of the church, and a sandstone plaque acknowledging Holmes's laying of the first stone of the building on 9 June 1787, are located above the doorway. About fifty metres towards the village, on the opposite side of the road, is the manse, still known as the Parade Manse on account of Holmes's activities in training the local Ballyeaston Yeomanry in the field below the house (see also p. 90).

Most of the villagers of Ballyeaston were presumably at odds with their minister's political views for this was the heartland of the United Irish organisation in south Antrim. Moreover, the village played a prominent part in the final decision to rise up in revolt. On 4 June 1798 a meeting of thirty-five Antrim 'colonels' assembled on Ballyboley Mountain, at a place known as the sheep-ree. From some there were calls for an immediate uprising but others proved more cautious, particularly as the

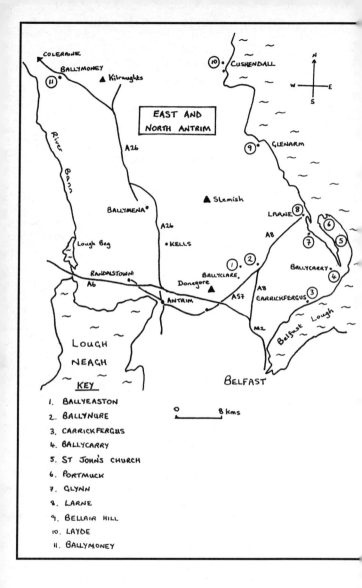

EAST AND NORTH ANTRIM

KEY

1. BALLYEASTON
2. BALLYNURE
3. CARRICKFERGUS
4. BALLYCARRY
5. ST JOHN'S CHURCH
6. PORTMUCK
7. GLYNN
8. LARNE
9. BELLAIR HILL
10. LAYDE
11. BALLYMONEY

promise of foreign aid was now known to have evaporated. When the meeting broke up in discord, many retired to Ballyeaston, where lower-ranking officers of the organisation, including men from Belfast, had assembled. Dismayed at the outcome of the earlier meeting, these men took matters into their own hands by electing Henry Joy McCracken as commander-in-chief and they called for the Rebellion to begin on 7 June by attacking Antrim and seizing the magistrates assembled there. Thus, on that day, a large turnout of Ballyeaston's insurgents were to turn east and assemble at Donegore Hill with their south Antrim neighbours. But the village was to pay heavily for its active involvement. On 10 June a military column consisting of three hundred men and two cannon marched from Carrickfergus and burned numerous houses at Ballyclare, Doagh and Ballyeaston before returning later that evening with their considerable plunder.

The village, as with many other former United Irish strongholds, was to swiftly return allegiance to the government. The *Belfast News-Letter* of 20 July carries a notice of a public meeting held in the village on 8 July and signed by 486 inhabitants, declaring their loyalty to the constitution.

BALLYNURE OLD GRAVEYARD

GRAVE OF THE REVEREND ADAM HILL

OS Sheet 15, 316935
From Ballyeaston take the road to Ballynure. At Ballynure village, stop on Church Road near the old graveyard, located on the right, near Christchurch Church of Ireland. Hill's grave is 12 m east of the roofed mausoleum in the centre of the graveyard. It is a horizontal slab within a railed enclosure containing other upright headstones. The wording is faint.

Adam Hill was born near Randalstown in 1757 and

educated in Scotland. In 1782 he was licensed by the Route Presbytery. He was later ordained for ministry in the USA but did not take up the post. Instead he was installed at Ballynure on 16 April 1785, where he was to remain for over forty years.

Ballynure was in the heartland of the United Irish movement in south Antrim and it was inevitable that Hill, like many other Presbyterian ministers, would become involved in contemporary events. Following the trial of William Orr at Carrickfergus in October 1797, Hill accompanied Orr as his chaplain in the same chaise from the gaol to the scaffold.

After the Rebellion Hill was accused of having been on Donegore Hill on 7 June and of acting as one of the leaders. His accuser was said to be a Presbyterian who was reluctant to see Hill hanged. Hill was found guilty of having been present on Donegore Hill and served a one-year sentence.

ST NICHOLAS'S CHURCH, CARRICKFERGUS

LOYALIST GRAVES

OS Sheet 15, 514875
St Nicholas's church is located in the centre of Carrickfergus just off the market square. From the square, enter the church graveyard and proceed to the far side, which backs on to Lancastrian Street.

GRAVE OF SAMUEL McSKIMIN

From the north side of the church tower proceed 30 m north to the graveyard boundary and the prominent white Celtic cross memorial. McSkimin's grave is directly facing this cross a few metres to the west. The inscription reads: 'To the memory of Samuel McSkimin Obit 1843 aged 68 years. Nancy McSkimin died 7th May 1857 aged 77 years . . .'

Samuel McSkimin, a Presbyterian, was born near

Ballyclare in 1775 and became a grocer in the Irish Quarter of Carrickfergus. He was a member of the yeomanry and it is his first-hand experience of the Rebellion which has proved so useful to historians. He wrote two major works, the *Annals of Ulster* and *History and Antiquities of the County of the Town of Carrickfergus*, and on his death he was said to be the foremost authority on the 1798 Rebellion.

He had six children by his wife, Nancy, and helped compile the 1821 and 1831 censuses. In 1818 he was enrolled as a freeman of Carrickfergus corporation. He died in 1843.

GRAVE OF CAPTAIN ANDREW MacNEVIN

From McSkimin's grave proceed to the north-west corner of the graveyard. Lying flat, directly in front of the elaborately carved Legg monument, is the grave of Captain MacNevin.

Andrew MacNevin was the captain of a company of army veterans at Carrickfergus known as the Old Fogies. At the end of June 1798, he received a message from the Reverend William Holmes of Ballyeaston that a 'band of robbers' (Henry Joy McCracken's band) was occupying Wee Collin Mountain and he was invited to remove them. As a result, McCracken's companions were dispersed and McCracken was later arrested near Carrickfergus.

Though clearly acting on the side of the government here, MacNevin had previously attempted to intervene in the trial of William Orr (see p. 108). Orr was pronounced guilty and sentenced to hang in October 1797. However on 7 October, MacNevin sent a message to Undersecretary Edward Cooke in Dublin informing him that he had interviewed a man who had been with one of the two principal prosecution witnesses, Hugh Wheatley, at Rasharkin, County Antrim, where he had appeared 'deranged in his understanding'. MacNevin urged caution in placing too much weight on Wheatley's testimony, hence putting the guilty verdict in doubt.

However, the appeal was unsuccessful and Orr was hanged on 14 October.

He is also presumably the same Captain MacNevin who forwarded to Dublin Castle in July 1791 a prospectus by William Drennan outlining the formation of a new radical society, which later became the United Irishmen. Drennan had carelessly allowed his written thoughts to be circulated outside of his trusted friends in Belfast and was soon dismayed to see it being read publicly in Dublin. Fortunately for Drennan the authorship of the prospectus was not revealed until well after his death.

BALLYCARRY

INSURGENT GRAVES

OS Sheet 15, 448937
From Carrickfergus take the A2 for Larne. After about 11 km
(7 miles) turn off on to the B90, signposted to Ballycarry. James
Orr's grave is situated in the graveyard of the old ruined
Presbyterian church at the south end of the village. Park beside the
small triangular park. Buried here, within the precincts of the old
church, are the remains of the Reverend Edward Brice who
established the first Presbyterian church in Ireland in 1613.

GRAVE OF JAMES ORR, THE 'BARD OF BALLYCARRY'

James Orr's grave is a large, railed monument 10 m in through a turnstile to the left. A former United Irishman, he is perhaps the best of the Ulster weaver poets of the late eighteenth and early nineteenth century. In style he resembles his contemporary Robert Burns, writing in both English and his own Ulster-Scots dialect, and today deserves greater recognition in his native land.

Born in 1770 in a single-storey thatched house 1.5 km (1 mile) west of Ballycarry, he was an only child. His father was a weaver on the nearby estate of Richard Gervase Ker of Redhall. Despite his humble upbringing his father taught him to read as he was too frail to go to school.

His parents were Calvinist in outlook but Orr was a radical of the 'New Light' tradition and a Freemason, and his views were not welcomed in the house. He began his literary career at an early age by composing secular verses for Psalm tunes. He became a United Irishman and contributed several poems to the *Northern Star*, among them 'The Tears of Liberty' and 'Virtue's Pole Star', though under a fictitious name. He was on Donegore Hill on 7 June and, following defeat, fled to the USA. However he only remained there for a few months before returning to Ballycarry, where he applied to join the local yeomanry in 1800, but was refused. Years later, he was to publish verses expressing his disillusionment with the Rebellion, notably 'Donegore Hill'.

He died in 1816 but the monument seen here today was erected by subscription in 1831. It describes him as a 'Poet, Patriot and Philanthropist'. A plaque has recently been erected to Orr's memory in the park near to the entrance of the graveyard.

GRAVE OF WILLIAM NELSON, THE 'BALLYCARRY MARTYR'

Nelson's grave is one of two slate headstones contained within a railed enclosure, 25 m from the east end of the ruined church, near the edge of the graveyard.

Numerous persons were to be tried and hanged for their part in the Rebellion and many of their names have gone unrecorded and are now lost to history. But every so often the particular circumstances surrounding an incident determine that it will enter folklore and serve to focus the judicial injustices of the period. The death of William Nelson, as with Betsy Gray, is one such example.

On 7 June the nearby mansion of Redhall, owned by Richard Gervase Ker, was attacked by insurgents from Islandmagee and Ballycarry. Their objective was the plentiful collection of small arms which Ker kept on the premises and they broke open the gun room and seized the weapons. Ker had wisely withdrawn to Carrickfergus but, before he did so, had disabled the weapons (probably

by removing the flints). Nevertheless, the insurgents headed off towards the rallying point at Donegore Hill with their defective arms.

One of their number was a young lad of sixteen named William (Willie) Nelson, an apprentice shoe-maker from Ballycarry. He procured one of Ker's horses from its stable and proceeded to tour the country to secure a greater turnout of insurgents. Later he returned the horse to Redhall but took another, on which he headed off for Donegore.

Shortly after the failure of the Rebellion he was arrested and taken to Carrickfergus. Attempts at bribery failed to elicit information regarding his compatriots. When he refused to divulge the information he was threatened with death. Eventually he was court martialled and, being found guilty, was sentenced to hang. Nelson's widowed mother appealed to Ker for clemency but the landlord was in no mood to intervene so Nelson was brought to Ballycarry for the sentence to be carried out. Tradition holds that he was executed by hanging from a sycamore tree located outside his home. The tree was later cut down by neighbours and removed from the gaze of his distraught mother.

However, the Nelson family ordeal was not yet over. Ker removed Mrs Nelson from her home. William's brother John, who had turned out at Antrim, was trans-ported for seven years and another brother Samuel was transported for life. George Anson McCleverty from Glynn is fondly remembered as the magistrate who inter-vened to prevent the two brothers receiving the same sentence as young William.

Nelson's execution is recorded in the 6 July edition of the *Belfast News-Letter*. Though the circumstances sur-rounding each case are different, it compares unfavour-ably with the sentence handed down to an unnamed young lad on trial at Downpatrick on 23 June. He was found guilty of having assisted the rebels to procure horses and sentenced only to military service.

GRAVE OF JAMES BURNS

Burn's grave is 4 m from Nelson's. It consists of a small upright marker, 0.5 m high, containing a lead tablet.

James Burns, born in 1772, was a colourful character who became involved in the Rebellion in County Antrim. A deserter from the Royal Irish Artillery, he had also joined the ranks of the Kilwaughter Defender association. At the Battle of Antrim on 7 June, he manned the single brass cannon of the insurgents, along with his father, a man named McGivern and a boy named Lynas. The gun was mounted on a crude carriage and it was not possible to raise or to lower it. During the engagement, it was fired only twice before a wounded horse fell over it, collapsing the carriage.

In the aftermath of the battle, Burns and a fellow insurgent named Paul Douglas, from Parkgate, near Ballyclare, managed to escape by killing two dragoons who were pursuing them across fields. He then fled to Scotland but soon returned only to be arrested and, following a trial, given the choice of transportation or military service abroad. He spent the next three years with the army at St Kitts before being released in 1802 and returning first to Kilwaughter and then to Ballycarry. He married and worked as a weaver with various local men.

Like James Orr, he was a Freemason and his gravestone was originally carved with a cryptic verse in which vowels were substituted by numbers. Unfortunately the script has now worn away but it once read:

> Christ was the word that spake it
> He took the bread and break it
> And what that word did make it
> That we believe and take it.

Burns had the piece, taken from a work entitled *The Practical Christian* (1698), etched on his gravestone prior to his own death. He died in 1862 in his ninety-second year.

ST JOHN'S PARISH CHURCH,
ISLANDMAGEE

GRAVE OF THE REVEREND
WILLIAM HOLMES

OS Sheet 9, 463979
From Ballycarry take the B90 to Islandmagee. At the junction
with the B150, take the Ballylumford road for 3 km (2 miles) to the
parish church of St John which dates from 1595. The Reverend
William Holmes is buried beneath a recumbent stone within a
high railed enclosure at the door of the church.

This grave inscription reads: 'Sacred to the memory of
the late Reverend William Holmes, Islandmagee, who
departed this life 30th November 1823 ae 84 years. He
was ordained to the pastoral charge of the Associate
Presbyterian Congregation of Ballyeaston in the year
1768 of which he continued 55 years minister . . .'

William Holmes was a native of Ramelton in County
Donegal, was licensed in Moira, County Down, and Lis-
burn, County Antrim, and ordained as the first minister
of Ballyeaston on 29 June 1768. He laid the foundation
stone of the present meeting-house in 1787 and remained
its pastor until he died. However, his ministry was not a
smooth one. He complained of his income from the
church being insufficient. He was charged with having
announced his intention to marry on only one occasion
instead of the legal requirement of three. Admitting his
error he was rebuked by the presbytery.

Holmes took a prominent and active part in the
Volunteer movement but, like many other liberals, he
was to align with the establishment when rebellion
threatened. In an area where so many inhabitants had
United Irish sympathies and where many were to have
an active role in the Rebellion, it was perhaps in-
evitable that he should clash with his congregation
(see p. 81).

PORTMUCK

HOME OF WILLIAM McCLELLAND,
INSURGENT LEADER

OS Sheet 9, 461024
*Continue north along the B90 for a few kilometres, turning right at
the signpost for Portmuck. Continue to Portmuck pier and park in
the car park. The farm on the headland on the east side of the bay
was the home of William McClelland, one of the insurgent leaders
in the Rebellion.*

William McClelland was born in 1776, the son of a prosperous farmer of Portmuck who owned a farm of fifty-eight acres. With William Curry of Ballycronan, he marshalled the United Irishmen of Islandmagee at Knowehead Brae and marched them to the rendezvous point at Redhall near Ballycarry where they linked up with the local contingent. This group were to head for Donegore Hill and may indeed have reached their destination but the Battle at Antrim had already been decided in favour of the government troops. As a result of this, the insurgents scattered and McClelland was forced to hide in a cave on Portmuck Island. A reward of fifty guineas was posted for his capture but he managed to evade his pursuers.

It is uncertain how long he remained hidden but he was later allowed to return to the family farm and to demonstrate his loyalty he joined the Islandmagee Yeomanry where he rose to the rank of lieutenant. He became a well-known and respected figure who earned himself a reputation as a modernising farmer, introducing mechanisation and constructing lime kilns for the production of lime as fertiliser. In 1829 he managed to persuade the Irish Fisheries Board to construct a pier and harbour at Portmuck. After a long and prosperous life, he died in 1859. The farm at Portmuck remained in the family's hands until very recent times.

The peninsula of Islandmagee contributed an

estimated one hundred and eighty insurgents to the Rebellion. The *Ordnance Survey Memoirs* record that the inhabitants 'to a man took a more or less active part in the turnout' but despite this, very few gravestones make any mention of the Rebellion. The fate of William Curry is uncertain but it is believed that he managed to escape to the United States.

GLYNN OLD GRAVEYARD

GRAVE OF GEORGE ANSON McCLEVERTY

OS Sheet 9, 408997
From Portmuck drive around Larne Lough to Glynn village,
joining the A2 Larne–Carrickfergus road. Just before the village of
Glynn turn left onto the gravel lane to St John's parish church
which runs beside a stream. Park at the entrance to the graveyard.
Below the east window of the ruined church is the walled enclosure
containing the box tomb of George Anson McCleverty.

This grave inscription reads: '. . . Also Jane McCleverty who died 8th Feb 1805 aged 86 years relict of Captain William McCleverty who died at Waterford 10th Dec 1779 aged 63 years . . . Also George Anson McCleverty Esq of Glynn who died 26th Dec 1821 aged 76 years, son of the above William McCleverty by Jane his wife'.

George Anson McCleverty was a magistrate who lived at the village of Glynn. As a member of the Head-of-the-Town Presbyterian congregation of Larne, he was acquainted with many of the active participants in the events of 1798, among them Edward Jones Agnew, James Agnew Farrell, Dr George Casement and the Reverend James Worrall.

On the morning of 7 June he was at home preparing to attend the meeting of magistrates at Antrim called by Lord O'Neill when he was abducted by a body of insurgents and brought to Larne. The intention of the insurgents was to use McCleverty to deliver a summons demanding the immediate surrender of Lieutenant Andrew Small and

the twenty or so Tay Fencibles who were surrounded in their barracks. McCleverty convinced his captors that such a proposal was unwise and the message was delivered by another hand. Small, however, refused to accede to the demands despite having sustained several casualties in earlier exchanges.

McCleverty now endeavoured to dissuade the insurgents from their intentions and urged them to surrender their weapons and return to their homes, promising to obtain leniency on their behalf. He requested the attendance of the local squire, Edward Jones Agnew, and when this was granted, the two men tried in vain to negotiate a cessation of the conflict.

In the meantime a false report arrived that Carrickfergus had fallen to the insurgents and at around 11 a.m. the insurgent army set off for the general rendezvous at Donegore Hill. Agnew was permitted to return home but McCleverty was taken along. The *Belfast News-Letter* of 12 June 1798 reported that he had been released on 8 June soon after the defeat at Antrim. He claimed to have persuaded fifteen hundred of the two thousand assembled there to leave and return home. It would appear he came to no harm and he survived a further twenty years. His father, Captain William McCleverty, is commemorated by a memorial in Holy Trinity Cathedral in Waterford; he had accompanied Commodore (later Lord) Anson in his round-the-world expedition and presumably named his son after him.

LARNE

SITE OF SKIRMISH ON 7 JUNE 1798

OS Sheet 9, 400027
The action took place along Pound Street and in Upper Cross
Street, where the present town hall is located, in the centre
of the town.

The first action in the 1798 Rebellion took place at Larne
in the late evening of 6 June 1798. The town was garri-
soned by Lieutenant Andrew Small and about twenty
men of the Loyal Tay Fencible Regiment who were
quartered in a house in Pound Street.

Around 10 p.m. news reached Dr George Casement, a
prominent citizen, who lived across the River Inver at
Casement Brae, that a rising was to occur in the town that
evening. Casement immediately warned Small who
went out with an armed patrol, together with a few
loyalists, to reconnoitre the town. They came across a
meeting of insurgents in the upper storey of a house and
managed to arrest four men, though the rest escaped.
Small confined the prisoners in his quarters and retired
to bed.

Nevertheless, around 3 a.m. on 7 June, some two hun-
dred and fifty insurgents (of whom about sixty were
armed) assembled at the Cold Well near Casement's
house and advanced into the town with the object of
attacking the garrison. Small was aroused from his sleep
and he set out with a party of the Tays to intercept the
attackers. However, his party was ambushed, two soldiers
were killed and another three seriously wounded, in-
cluding Small. The insurgents suffered one dead and one
wounded.

The soldiers managed to extricate themselves and
retreated to their barracks, taking their wounded with
them, and there they remained for the rest of the
day. This left the insurgents in control of Larne. Later
that morning an insurgent contingent arrived from

Ballycarry, but, on hearing the false report that Carrickfergus had fallen, set off for the assembly at Donegore Hill with their colleagues from Larne and Islandmagee. A group of around sixty, armed with pikes, remained on Islandmagee at a vantage point overlooking Larne harbour. In mid-afternoon, Lieutenant Ellis arrived at Larne with some of his troop of cavalry but left shortly afterwards. Small's garrison was then withdrawn to Carrickfergus.

MEETINGHOUSE STREET, HEAD-OF-THE-TOWN CHURCH

OS Sheet 9, 396026
From the town hall, proceed uphill to the junction with Pound Street. Turn left along Pound Street and proceed for about 300 m to Meetinghouse Street. The Head-of-the-Town church is on the left, about 50 m along this road.

The Head-of-the-Town Presbyterian church, also known as the Old Presbyterian congregation of Larne and Kilwaughter, was formed in the 1620s. The present building was completed in November 1829 on the site of the former thatched church.

During the debate over non-subscription in the early eighteenth century, the church had opted to join the Presbytery of Antrim whose congregations formed the 'New Light' movement in Presbyterianism. The controversy over non-subscription centred around the refusal of certain Presbyterians to accept the 1643 Westminster Confession of Faith as the definitive doctrine of the Presbyterian Church. Non-subscribers argued that the imposition of man-made tests or confessions of faith restricted the sacred right of private judgement.

'New Light' congregations were to be actively involved in the radical politics of the late eighteenth century and the Head-of-the-Town congregation was no exception. However, not all members supported armed insurrection.

In 1796 the Reverend James Worrall, an active United

Irishman, became the seventh minister of the congregation. A native of Limerick, he had been an Anglican, but following his education at Trinity College Dublin he became a Presbyterian and moved to Ulster where he acted for a time as tutor to the Turnlys of Rockport, County Antrim. When the pulpit at Larne became vacant, he was unanimously called to serve the congregation there.

However Worrall's ministry was not a particularly beneficial one for the congregation. He was always in poor health, suffering from asthma, and after a short time his duties became confined to the preparation and performance of his pulpit services. More damaging to the income of the congregation was his refusal to accept on its behalf the 'Kilwaughter Stipend'. This stipend was part of the rent which tenants paid to their landlord, Edward Jones Agnew of Kilwaughter, for the occupancy of their land, traditionally paid back by Agnew to the congregation. Worrall probably viewed this income as he did the tithes paid to the Anglican church, which the United Irishmen opposed. However his action deprived future generations of a much needed source of church income and only served to benefit the landlord, as tenants were still obliged to pay the money to him.

Worrall is most notorious, however, for the leadership of his local United Irish society. He was implicated in the action of 7 June 1798, though due to ill health was probably not directly involved. Nonetheless he was to serve a short spell in Carrickfergus gaol. On his release he returned to his pulpit but resigned in May 1807 to take charge of the congregation at Clonmel in County Tipperary, where he remained until his death on 28 November 1824. Strangely enough, whilst residing there he became a zealous loyalist who, according to the biographer, Classon Porter, 'shocked even the Orange squires of Tipperary'. During his ministry at the Head-of-the-Town church, Edward Jones Agnew, James Agnew Farrell, George Anson McCleverty and Dr George Casement were all members. Worrall's radical

politics are reputed to have caused many of the more politically cautious, including Casement, to resign.

BELLAIR HILL

INSURGENT ASSEMBLY OF 7 JUNE 1798

OS Sheet 9, 295155
Continue out of Larne on the A2 towards Glenarm and turn left
on to the Dickeystown Road immediately before the village. After
about 400 m there is a superb panoramic view north-east over
Glenarm village and castle to Bellair Hill beyond. The hill itself is
difficult to access and is probably best avoided.

Early on 7 June, large numbers of insurgents from the neighbouring Glens of Antrim began to assemble on Bellair Hill, which overlooks Glenarm village from the north-west. At this time the village contained a garrison of sixty Glenarm Yeomanry and some Tay Fencibles under the command of Captain George Stewart.

Stewart was soon aware of the nature of the gathering and decided to take the pre-emptive measure of arresting the three principal known leaders, including the Reverend Robert Acheson, who was Presbyterian minister of the village church. Stewart then withdrew his troops into Glenarm Castle. The insurgents reacted by rounding up relatives of the yeomanry and marched them off to Bellair Hill, where they threatened them harm if Acheson and the others were not released.

Edward Jones Agnew of Kilwaughter Castle, a member of Larne Non-subscribing congregation, now intervened to broker an exchange of prisoners. This was quickly achieved and Acheson and his fellow prisoners were released by the military. However Acheson immediately donned his uniform and ascended Bellair Hill to take command of the insurgent assembly, numbering between eighteen hundred and two thousand people. The atmosphere on the hill was pleasant

throughout the day with the women attending to their men over camp fires and moving among them with food and drink.

Agnew understood the gravity of this illegal assembly and he continued to press Acheson to consider his position. By 8 June, news of the defeat at Antrim was well known and Acheson agreed to parley with Stewart. Stewart offered an amnesty for everyone, except those who had carried out atrocities, and a further exchange of prisoners took place. By dawn on 9 June no one remained on Bellair Hill.

Stewart's amnesty offer included Acheson but the minister was to stand trial in Belfast, along with Alexander Stewart and Pat Magill. All were acquitted on 28 July. Meanwhile General Nugent, commander of forces in the north of Ireland, praised Stewart's defence of Glenarm in a public notice on 19 June.

LAYDE CHURCH, CUSHENDALL

GRAVE OF DR JAMES McDONNELL

OS Sheet 5, 246289
Proceed along the A2 coast road to Cushendall, turning right in the village on the road to Layde. After approximately 1.5 km (1 mile), Layde church is reached. Park in the car park and walk down the lane to the ruined church. In the north-west corner of the graveyard, adjacent to the church gable, is the tall Celtic cross monument to James McDonnell.

This grave inscription reads: 'Erected in memory of James McDonnell, of Belfast and Murlough, in this country; a Physician whose great abilities and greater benevolence made him venerated in the Glens of Antrim, where he was born, and in Belfast, where he died AD 1845, in his 82nd year.'

An eminent figure and close associate of all the major personalities involved in the events of the 1790s, James McDonnell is today best remembered for his pioneering

medical work in Belfast which established proper hospital care for the grateful citizens of the town. However, his numerous friendships with many of Belfast's leading political figures were to place him in awkward situations and on at least two occasions he was to come into conflict with his friends.

Born in Cushendall in 1762, he received his early education in the Red Bay cave school of Maurice Traynor and later at David Manson's school in Belfast. He studied medicine at Edinburgh, his thesis assessing methods of artificial resuscitation, and graduated MD in 1784. He returned to Belfast where he set up his practice and later became a distinguished physician.

In 1792 he helped organise the Belfast Harp Festival and later in life paid a £30 annuity to one of the harpists, Arthur O'Neill, for the remainder of his life. In April 1797 he was a founder of the Belfast Fever Hospital at premises in Factory Row (now Berry Street), the forerunner of the Royal Victoria Hospital.

Described as tall and handsome, McDonnell was, however, to prove unpredictable and sometimes disappointing to his erstwhile friends. He became a close associate of Thomas Russell's and John Templeton's, with whom he shared an interest in the natural sciences; he was also on good terms with Henry Joy McCracken and Samuel Neilson and was certainly aware of the United Irishmen, though not himself a member. Wolfe Tone called him 'The Hypocrite' ostensibly on account of his medical background but in the light of his actions this may have been ironic.

Following Henry Joy McCracken's hanging outside Belfast Market House on 17 July 1798, his body was taken down and removed to his home in Rosemary Street. His friend Dr McDonnell was sent for in order to attempt to revive the corpse but he declined and sent his brother Alexander, a surgeon, whose attempts at resuscitation were unsuccessful.

In 1803, McDonnell further disappointed his former friends when he agreed to donate £50 to a sum of £500

which the town Sovereign was attempting to raise as a reward for the capture of Thomas Russell. This was in spite of being an intimate associate of Russell's, with whom he maintained correspondence whilst Russell had languished in gaol in Fort George. It was an act which McDonnell's friends found difficult to forgive and it was over twenty years before John Templeton reluctantly agreed to patch up the difference.

However, his medical reputation was to carry him and he died a much respected figure in the growing town of Belfast. He appears to have at least regretted his actions and years later records that 'in signing that paper [for £50 donation] I did what I then considered and what I now consider a solemn duty, but I had not done it one hour until I wished of all things it was undone'.

BALLYMONEY

OS Sheets 4/8, 949259

Ballymoney is easily missed by day-trippers from Belfast, who use the bypass to reach the north Antrim coast beyond. However, it contains an architecturally pleasing and historically important centre, its former wealth having been derived from the linen industry.

The town was the focus of United Irish activity in the 1790s. On 8 June 1798, local insurgents were to gather on Kilraughts Hill, 8 km (5 miles) to the east, with the intention of marching on Coleraine as part of Henry Joy McCracken's plan to seize local centres of administration. However, the following day a force of two hundred and twenty of the Manx Fencibles, four corps of yeomen cavalry and two curricle guns left Coleraine under their colonel, Lord Henry Murray, son of the Duke of Athol, to suppress the Rebellion in the area. This force was observed by the Ballymoney insurgents, on their way to the assembly site, who considered them too formidable and consequently dispersed. Murray's troops reached Ballymoney and as punishment, set fire to the homes of

the insurgent leaders before returning to Coleraine. However, the indiscriminate fashion of this punitive measure led to a large bill for compensation being presented to the government by angry loyalists in the town.

OLD CHURCH GRAVEYARD:
LOYALIST AND INSURGENT GRAVES

Obtain the key of the graveyard from Ballymoney District Council offices on High Street during normal office hours. Proceed down High Street and turn left into Church Street, where the graveyard entrance is located.

GRAVE OF GEORGE HUTCHINSON

Proceed up the steps to the door of the old church tower. At the rear (east) side of the tower in a high-walled and railed enclosure is the family burying ground of George Hutchinson. His grave is marked by a recumbent slab in the floor of the plot, and his wife is commemorated by a white marble tablet in a sandstone surround in the wall: 'Sacred to the memory of George Hutchinson Esq of Ballymoney, Obt, First of July 1845 Ae 84 years'.

George Hutchinson was a JP, known locally as 'Bloody Hutchinson' on account of his reputation for the summary justice he handed out to United Irishmen in 1798. His ghost is reputed to wander the town to this day.

Hutchinson's behaviour may in part be attributable to his treatment at the hands of the insurgents. As with other magistrates, he had been summoned to a meeting in Antrim on 7 June by Lord O'Neill and had accompanied David Leslie of Leslie Hill. Both men had avoided the hostilities which had taken place in the town and were on their way home when they were stopped by a party of United Irishmen who identified them and dragged them from their carriage. They would have been killed immediately had it not been for the intervention of Dr Wilson of Cullybackey who subsequently accompanied them back to their respective homes.

GRAVE OF ALEXANDER GAMBLE

From the door of the old tower, proceed approximately 25 m south down the graveyard to a yew tree. From here walk another 25 m east to a group of four upright stones under the shade of yew trees. Gamble's grave is one of these. The inscription reads as follows:

> In memory of Alexander Gamble of Ballymoney, an insurgent of 98, who was executed and buried in Ballymoney Market Square on 25 June 1798 aged 35 years. Raised and re-interred here on 14 September 1883. Catherine Maclure, his wife. Died 14 February 1845 aged 84 years. They rose in dark and evil days to right their native land.

The *Belfast News-Letter* records the court martial of Alexander Gamble on charges of treason and rebellion in its 29 June 1798 edition; Gamble was found guilty and executed in the market square before being buried at the foot of the gallows: 'He was extremely penitent – confessed his crime – and acknowledged the justice of his sentence'. In 1883, workmen laying water pipes in the street uncovered the coffin and relatives of the deceased had the body re-interred in this graveyard.

THE DIAMOND AREA

From the graveyard, return along Church Street to the junction with High Street and Main Street. This area is known as the Diamond.

THE MASONIC HALL AND TOWN CLOCK, MAIN STREET

This building was erected in 1775 by Randal, sixth Earl and second Marquess of Antrim, as a market house (the campanile dates from 1852). The Reverend John Wesley preached here in 1785. Alexander Gamble's execution took place outside the hall.

ASSEMBLY ROOMS (NOW THE NORTHERN BANK BUILDING),
HIGH STREET

This building was erected around 1760 by Alexander, fifth Earl of Antrim, at his own expense as Assembly Rooms. During the Rebellion and Napoleonic period it was used as a barracks for government troops.

BALLYMONEY MUSEUM AND HERITAGE CENTRE,
33 CHARLOTTE STREET

Proceed down Charlotte Street. This street, formerly known as Pyper Row, contains a good surviving example of a late-Georgian terrace, with original door cases, windows and fanlights. The museum is housed in this terrace and contains several interesting artefacts from the Rebellion period.

Most unusual are the three small, well-carved, wooden figures of French revolutionaries known as 'Sans Culottes'. These items may have been brought from France to north Antrim, and they illustrate the connection between the United Irishmen and the French Revolution. The figures depict typical French workers in their revolutionary clothing. Also on view is a sword which belonged to John Nevin of Kilmoyle, a prominent United Irishman in the district. Nevin was heavily implicated in the Rebellion and was exiled to America where he died. A glazed jug commemorating Nevin is on display and the inscription records his exile: 'To the memory of John Nevin of Kilmoyle, who was by the Foes of Reform, banished from his native home in June 1798. He lived in the state of Exile 7 years 11 months 8 days and departed this life in Knoxfield, Tennisee [sic] ye 19th May 1806 . . .'

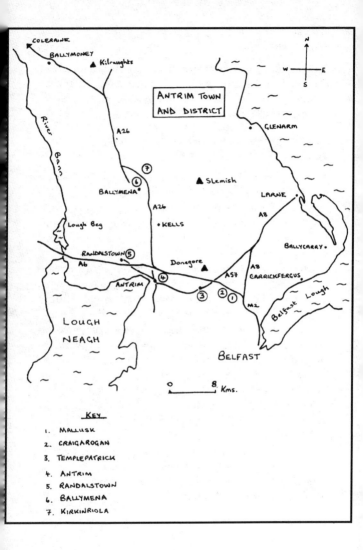

ANTRIM TOWN AND DISTRICT

This tour covers the Battle of Antrim and follows the approximate route taken by the insurgents under Henry Joy McCracken, detailing several sites of interest along the way, before continuing to Randalstown and concluding at Ballymena.

MALLUSK

GRAVE OF JAMES HOPE

OS Sheet 15, 287832
From Belfast, travelling northwards on the M2, come off the motorway at Sandyknowes (junction 4) and take the road signposted for Mallusk (Scullions Road). At the end of this road, turn right onto Mallusk Road. The graveyard is 2 km (1.25 miles) on the right, at the junction with Park Road. Hope's grave is at the rear, almost directly in line with the entrance gates, a tall upright plinth about 2 m high.

James Hope, a hand-loom weaver, was born near Templepatrick in 1764. He became a Volunteer before joining the United Irishmen in 1795. He was an important liaison officer, carrying executive decisions to committee members within the organisation. He took part in the Battle of Antrim, covering the insurgent army's retreat, and his small force later became known as the Spartan Band. After the Rebellion he was forced to live in Dublin and elsewhere for several years. He joined Russell in a plan to raise Antrim and Down during the 1803 rebellion of Robert Emmet. Fortunately for him it was aborted and he was able to spend his later years in Mallusk.

CRAIGAROGAN HILL

WHERE McCRACKEN RAISED THE STANDARD OF REBELLION

OS Sheet 15, 270839
Continue along the Mallusk Road towards Templepatrick (B95)
for about 2 km (1.25 miles). At Roughfort crossroads turn right.
About 250 m on the right is a small, tree-lined mound which is
approachable over a fence.

The small tree-covered mound of Craigarogan was chosen by Henry Joy McCracken as his assembly point for the march to Antrim on 7 June. About one hundred assembled here, including James Hope, many being former members of the old Roughfort Volunteers. Hope had fled from Belfast the previous evening on a cart containing swords, a green jacket and the green standard which was now unfurled and planted on the summit.

After some time, a horseman arrived and informed the assembly that the country was up in arms and that Larne had fallen to the insurgents. Presently a large contingent arrived from Carnmoney under the command of a young farmer called Joseph Blackburn from Whiteabbey. Later, when sufficient numbers had arrived, they were formed into three units and headed off for Antrim via Templepatrick.

Today Craigarogan appears from the road as a rather inconspicuous mound but from the summit there are good views north and east across the valley of the Sixmilewater.

TEMPLEPATRICK

PRESBYTERIAN MEETING-HOUSE:
INSURGENT ARTILLERY STORED HERE

OS Sheet 14, 228857
Proceed along the Templepatrick road for about another 6 km
(3.75 miles) until the village is reached. At the junction with the
busy airport road, the entrance to Templepatrick meeting-house can
be seen through the gates in the high stone wall which surrounds
Castle Upton estate.

This meeting-house is one of the earliest Presbyterian churches in Ireland, dating from the beginning of the seventeenth century. In 1798, two brass six-pounder cannon, belonging formerly to the Blue Battalion of the Belfast Volunteers, were brought from Belfast and hidden under the floor of the church. It is likely that the minister, the Reverend Robert Campbell, was unaware that the cannon had been placed in the church but was sympathetic to the popular cause.

On 7 June the two cannon were raised but one was deemed to be unserviceable. The other was mounted on a timber carriage belonging to Lord Templetown by the local blacksmith, using iron straps. The crew consisted of deserters from the Royal Irish Artillery, among them a young man named James Burns. There was no portfire or slowmatch for the gun and instead an iron pot full of burning peat was substituted.

The cannon was fired only twice at the Battle of Antrim before it became immobilised by a cavalry horse which fell across it and broke the carriage. After the battle it was claimed by the Monaghan Militia who brought it back to Belfast on 9 June. The other cannon had been surrendered to the military the previous day.

TEMPLETOWN OLD GRAVEYARD

WILLIAM ORR'S GRAVE

OS Sheet 14, 228859
This site can be reached on foot from Templepatrick Meeting-
house. About 100 m west of the meeting-house is the entrance to
the signposted National Trust property of Templetown
Mausoleum. Once within the grounds of the Castle Upton estate,
follow the sign marked 'old graveyard'. Orr's grave is directly
ahead, about 30 m through the double gates of the graveyard. Orr is
buried in the same grave as his sister Alice (Ally) who died in 1791.

William Orr was a weaver from the townland of
Farranshane, near Antrim. He was accused by Hugh
Wheatley and John Lindsay, soldiers in the Fifeshire
Regiment, of having administered to them the oath of
the Society of United Irishmen in April 1796. This oath
had become a capital offence under the Insurrection Act
of February 1796 and there was great interest in the trial,
as Orr was a popular local man.

Both Wheatley and Lindsay proved to be untrust-
worthy witnesses and there was a strong suspicion that
the authorities were putting on pressure to achieve a con-
viction. This was further supported by members of the
jury who later complained that they had been threatened
with ruin if they did not find Orr guilty. Orr was found
guilty and was hanged at Carrickfergus on 14 October
1797. The injustice of Orr's execution, however, was to
rumble on, and 'Remember Orr!' became a rallying cry
of the United Irishmen in the following months.

The nearby mausoleum of white limestone is worth
viewing as an example of architecture from this period,
as is the adjoining Castle Upton estate, part of which
was designed by Robert Adam in 1788. The mausoleum
contains a memorial to John Henry, first Viscount
Templetown (1771–1846), along with other descendants
of the family. Directly outside the mausoleum are the
graves of ministers of Templepatrick meeting-house,
including that of Josias Welsh (1598–1634), grandson of

John Knox, who was incumbent from 1622 to 1634. Also present is the white limestone grave of the Reverend Robert Campbell (1771–1855), minister of Templepatrick from 1796 until his death. Campbell was an important figure in early-nineteenth-century Presbyterianism: he was one of the seventeen ministers who refused to sign articles of faith at the 1829 Synod of Ulster and seceded to form the Non-subscribing Presbyterian Church.

ANTRIM

BATTLE OF 7 JUNE 1798

OS Sheet 14, 148866
The main action took place in the centre of the town,
along High Street and Church Street.

Henry Joy McCracken was popularly elected adjutant-general on 4 June 1798 after the resignation of Robert Simms. Under this younger, more radical leadership, an armed insurrection was immediately planned. McCracken called for a general uprising throughout Ulster on 7 June with himself leading a surprise attack by south Antrim insurgents on the assembly of magistrates at Antrim called by Lord O'Neill. Early on 7 June, McCracken raised the standard of rebellion at Craigarogan Hill at Roughfort and marched towards Antrim, gathering reinforcements on the way. At Templepatrick the army's only artillery, a six-pounder cannon, was lifted from its hiding place beneath the floor of the meeting-house and, manned by army deserters, accompanied the column to Antrim (see p. 107).

Unknown to McCracken his plans were already in the hands of the military commander in Belfast, General Nugent. Early on 7 June Nugent instructed Colonel James Durham to gather together a mixed force from the town's garrison, consisting of two hundred and fifty Monaghan Militia, a troop of the 22nd Dragoons, the Belfast Yeomanry Cavalry and two six-pounder cannon,

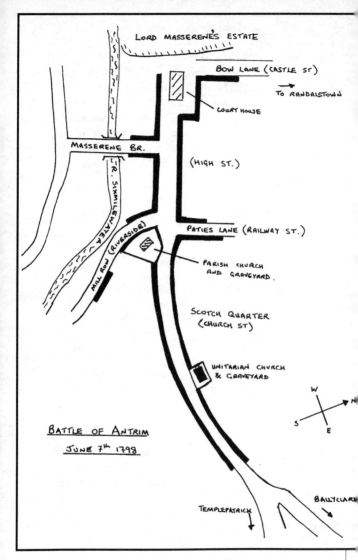

LORD MASSERENE'S ESTATE

BOW LANE (CASTLE ST)

→ TO RANDALSTOWN

COURT HOUSE

MASSERENE BR.

(HIGH ST.)

R. SIXMILEWATER

MILL ROW (RIVERSIDE)

PATIES LANE (RAILWAY ST.)

PARISH CHURCH AND GRAVEYARD.

SCOTCH QUARTER (CHURCH ST)

UNITARIAN CHURCH & GRAVEYARD

W N
S E

BATTLE OF ANTRIM
JUNE 7th 1798

TEMPLEPATRICK

BALLYCLARE

totalling around four hundred men. These set off immediately for Antrim. Nugent also sent word to Colonel Clavering at Blaris Moor near Lisburn, and ordered him to assemble the 64th Infantry Regiment (Thomas Russell's former regiment), the 3rd Light Battalion

together with two howitzers, totalling perhaps one thousand men to march on Antrim. This force would take a considerable time to march the twenty miles (32 km) to Antrim so Clavering sent Colonel Lumley ahead with two troops of the 22nd Dragoons, a troop of Magheragall Yeomanry Cavalry and two six-pounder cannon.

Meanwhile in Antrim the local garrison under the command of Major Seddon had also been informed of the imminent rising by 9 a.m. His garrison was modest; some troops of the 2nd Dragoons, a troop of Masserene Yeomanry Cavalry and some forty to eighty armed loyalists – less than two hundred in total. Seddon set about arresting all suspected insurgents in the town and set fire to their property as a warning to others. He then made preparations for the forthcoming battle. He placed his yeomen and loyalists in the court-house and in front of the gardens of Masserene Castle at the west end of the town. The dragoons were kept in reserve at the side of the court-house. Around 1.30 p.m. McCracken's column linked up with the contingent from Ballyclare at Scotch Quarter (now Church Street) at the east end of the town. Estimates of their number vary but it may have been as much as five thousand. Of these, only one in five had firearms. The remainder carried pikes or farm utensils. There was initial hesitation, as the houses set on fire by Seddon had thrown a veil of smoke over the town. It was an hour before McCracken managed to persuade and cajole his army forward but at length there was an agreed plan of attack.

McCracken was to lead the main force down Scotch Quarter in a frontal assault while John Storey was to make a wide circling move north around the town and enter via Paties Lane (now Railway Street). The Ballyclare column was to take an even wider arc and enter via Bow Lane (now Castle Street) opposite the court-house. McCracken was also hoping for support from the Randalstown United Irishmen but could not be certain when they might arrive. Around 2.30 p.m. all the units set off on their agreed routes.

Suddenly Lumley's advance column of cavalry and artillery clattered over Masserene Bridge (now Bridge Street) and entered High Street. Immediately he positioned his cannon to fire down Scotch Quarter and echeloned the yeomen in support behind, with the dragoons in reserve at the rear. In minutes Lumley's cannon were firing canister shot at point blank range down the street at the advancing insurgent column. The initiative appeared to swing in favour of the military.

However Lumley's view down the street was obscured by smoke from burning buildings and in fact his guns were having little effect. Meanwhile McCracken's column had reached the parish church at the head of Mill Row (now Riverside) where they took up positions of comparative safety behind the stone wall. Lumley observed that the insurgents' returned fire had diminished and he ordered his dragoons forward to clear the street. It was to prove a bad decision, for the insurgents reformed in sufficient numbers to present a phalanx of pikes on the street and Lumley's dragoons were assailed by flanking musket fire as they galloped past the musketeers in the churchyard. In a minute, Lumley's rash charge had cost him five officers and forty-seven men, one third of his force, and the survivors retreated in some disorder over Masserene Bridge. Simultaneously the artillery pulled back to a position opposite Bow Lane while the yeomanry retired into the castle grounds and took up position behind the stone wall.

John Storey had been unable to persuade his column to enter the street at Paties Lane but the Ballyclare column had at last reached Bow Lane. There it was instantly assailed by musketry from the castle grounds. However the move had outflanked the artillery which was now vulnerable to its small arms fire. After sustaining a few casualties the artillery abandoned its guns. Lord O'Neill, who had been sheltering at the entrance to Bow Lane, was killed as he attempted to reach the safety of Masserene estate. Despite this success, it was clear to McCracken that no amount of coercion could persuade

the insurgents in Bow Lane to make a frontal assault. In order to stiffen their resolve he began to manoeuvre his own troops, including the musketeers in the parish church, around the back of the houses on High Street to Bow Lane.

At precisely this moment the Randalstown column reached the outskirts of the town and observed some of the dragoons fleeing. Unaware of the situation this column mistook the fleeing dragoons as an attacking force and instantly dissolved into an unsightly mob of terrified fugitives. Soon after this, Durham's force arrived from Belfast and posted itself on Sentry Hill near the town. As Durham was unable to see what was happening in the town centre, he began a cannonade of the town lasting half an hour. Observing all this McCracken's force refused to move and indeed many began to melt away across the fields. For the remaining insurgents the battle was now lost.

McCracken attempted to evacuate the remnants of his army northwards out of the town. The last to leave was a group at the graveyard commanded by James Hope of Mallusk, afterwards known as the Spartan Band. The inevitable flight of insurgents pursued by victorious yeomanry continued for the rest of the day. It is estimated that over one hundred insurgents were killed in the town and another two hundred in the pursuit. The military losses were not detailed but included over fifty dragoons lost in the charge down High Street.

The defeat of the United Irish army here ended the Rebellion in County Antrim. Though other towns in the county were to remain in the hands of the insurgents for the next forty-eight hours, no effective fighting force could be organised to continue the resistance. McCracken and his survivors were to flee, first to Ballymena and then Slemish Mountain before they finally dispersed towards the end of June.

SCOTCH QUARTER (NOW CHURCH STREET)

This is where the columns from Templepatrick and Ballyclare converged, remaining idle for up to an hour. On the north side of the road is the blue Unitarian church of 1700, now boarded up. In the graveyard, 15 m from the church and surrounded by yew trees, is the grave of William Eckles who was killed at Antrim on 7 June 1798. He was forty-six years old. Ironically Eckles, a loyalist, had gone out to greet the troops after the battle but was mistaken for an insurgent and shot dead.

PARISH CHURCH

This late-sixteenth-century church, surrounded by a stone wall, stands at the corner of Church Street and Riverside. The wall and grounds provided excellent cover for McCracken's musketeers and pikemen who had advanced down Scotch Quarter to occupy the site. From here, the charge of Lumley's dragoons was observed and accurate musketry was directed against them as they passed.

PATIES LANE (NOW RAILWAY STREET)

This road was used as a line of approach by a column of insurgents under John Storey. The column refused to enter the main street from this lane due to the heavy fire already taking place between the military and insurgents approaching from Scotch Quarter. Despite pleading and threats from Storey, many in the column ran off.

John Storey was arrested and stood trial at Belfast on Friday 29 June for his involvement in the Battle of Antrim in which he was accused of being a leader. One witness swore that he had seen Storey with 'a sword in his hand . . . hurrying them forward' at Paties Lane. Storey insisted he was innocent and the court agreed to adjourn to the next day in order that he could produce witnesses. The following morning, his father appeared in the witness box and swore that his son had dined with him between one and two o'clock before returning to work

in the potato field, where his father had again seen him around four o'clock. Despite this the court found Storey guilty and he was hanged in front of the market house at 3.30 p.m. after which his body was taken down, his head severed and placed on a spike.

MASSERENE BRIDGE (NOW BRIDGE STREET)

It was across this eighteenth-century bridge that Lumley's reinforcements arrived in mid-afternoon. He positioned his two cannon just west of the entrance to Bridge Street, on each side of High Street, with the yeomen and dragoons echeloned behind.

COURT-HOUSE

This was the initial front line of Seddon's yeomen before their retreat into the castle gardens. At a house near the north side of the court-house, Lord O'Neill was mortally stabbed by a pike.

BOW LANE (NOW CASTLE STREET)

From here the dragoons, sheltering from the musket fire in High Street, trotted off on the approach of McCracken's column. This in turn caused Samuel Orr's Randalstown column, which was approaching the town at the time, to scatter.

MASSERENE GARDENS

Though the site now appears denuded, this was the final position of the yeomen, after they had retreated from High Street. From here they were able to direct fire up the street from behind strong defensive positions. Thus the United Irishmen were unable to dislodge them and claim victory at Antrim.

RANDALSTOWN

SITE OF SKIRMISH ON 7 JUNE 1798

OS Sheet 14, 081902
Take the A6 from Antrim to Randalstown, passing the wall of
Shane's Castle estate, home of Lord O'Neill, killed at the Battle of
Antrim. In Randalstown, take the Toome Road (New Street).
About 400 m along on the left is the town's library which was
originally a market house, built in 1831.

Randalstown was the scene of a skirmish on 7 June
1798. Early that morning several columns of insurgents
descended upon the town from various directions, carry-
ing banners representing both Defender and United Irish
units. The fifty or so Toome Yeomanry were under the
command of Captain Henry Ellis and a Lieutenant Jones.
Initially Ellis drew up his troops across Main Street to
confront the rebels but, probably because of the large
numbers and fear of being taken in the rear, he retired
his troops to the upper room of the market house, secur-
ing the gates on the ground floor.

After a short period of desultory firing, the insurgents
managed to place burning straw through the gates, pro-
ducing large quantities of smoke. Ellis and his men were
in danger of being suffocated, and surrendered. Ellis and
Jones were transferred to Ballymena where they were
imprisoned in the market house there. The remainder of
the troops were marched off to a camp at Grogan's Island
near Randalstown.

The insurgents left a garrison in the town whilst
another group marched to Toome to dismantle the bridge
across the River Bann. The main group, under Samuel
Orr, George Dickson, Con Maginnis and a man named
Halliday, set off to assist McCracken at Antrim. However,
following McCracken's defeat, Randalstown was burned
by Colonel Anstruther on 8 June.

The market house here in New Street is not the actual
site of the skirmish. It took place at the original market

house on the south side of Main Street. The *Ordnance Survey Memoirs* recorded the existence of both buildings in the 1830s. Old and new market houses were almost identical in size. The old one, described as having three large round-headed arches, was erected by Lord O'Neill in 1770.

BALLYMENA

SITE OF SKIRMISH ON 7 JUNE 1798

THE MARKET HOUSE

OS Sheet 9, 108032
The site of the old market house around which the skirmish took place on 7 June is occupied now by the town hall, located at the junction of Bridge Street, Church Street, Mill Street and Castle Street, in the town centre.

The market house which formerly stood here was built in 1754 and consisted of a two-storey building, erected at the junction of Bridge Street and Mill Street. The lower storey was arcaded and served as a market place. The upper storey, which had a further two rooms off it, was used as a court-house. Access to the upper storey was via a stone stairway external to the building on Mill Street.

Early on 7 June the yeomanry garrison in Ballymena escorted two of the town's local magistrates to the meeting at Antrim called by Lord O'Neill, leaving behind only six of their colleagues. At noon, other yeomen from Portglenone brought in two prisoners who had been arrested while trying to raise the Rebellion there. Local loyalists were then invited to assemble at the market house to receive arms with which they were to secure the town.

Around 2 p.m. reports arrived that a large body of insurgents was descending on the town from Brough-shane. A local magistrate, the Reverend William McCleverty, accompanied by four yeomen, rode out of

the town to confirm this news. When they were about one mile out of the town, they came within sight of the insurgents. They were instantly fired upon and McCleverty's horse threw him. The yeomen immediately fled back to the town and McCleverty was captured and assaulted by the mob before being taken back to Ballymena.

Led by Robert Davison, a schoolteacher from Broughshane, the remaining yeomen and loyalists now resolved to barricade themselves in the upper storey of the market house, first securing the gates of the lower storey to prevent access. The insurgent column, several thousand strong and led by a well-armed contingent from the nearby Braid area, appeared down Church Street and opened fire on the market house. An ineffectual cross-fire now took place which resulted in few casualties. At this moment sixteen Dunseverick Yeomanry, under the command of Lieutenant Hugh McCambridge, were returning from Antrim across Harryville Bridge. They were surrounded by the mass of insurgents and taken prisoner.

At the market house, the exchange of shots continued. Eventually the ground floor gates were forced open and a burning tar barrel, fuelled by straw bales, placed on the floor. The occupants now faced being burned or suffocated, and they signalled to surrender. However, as they filed down the stone stairs, someone opened fire, wounding two of the loyalists. Davison returned fire, wounding the attacker. Fire was now directed by other insurgents at those exposed on the steps and three loyalists were killed before order was restored.

All the prisoners were now taken to a small airless cell, located under the market house. Conditions were extremely cramped and towards dawn the following morning, the prisoners requested water. Their captors acquiesced but during this time some of the assembled crowd attempted to drag Davison away. Davison stoutly defended himself but was eventually overpowered and repeatedly stabbed with numerous pikes. His mutilated

body remained on the street all day. He was later buried in the church graveyard.

At noon the town constable, William Crawford, was also removed from the cell by James Dickey, an attorney and prominent United Irishman from Crumlin, who had apparently taken command of the insurgent army at Ballymena (see below). Dickey accused Crawford of being an informer and, despite the latter's desperate pleas for mercy, he was executed by Dickey who stabbed him with his sword, one of the blows almost severing his head from his body.

During the period of the insurgents' control of Ballymena, other prisoners were brought in from surrounding areas, including the officers captured at Randalstown, Captain Henry Ellis and Lieutenant Jones. However, with the arrival of Colonel Clavering's troops on 9 June, the remaining prisoners were released.

BRIDGE STREET: SITE OF FRANK DIXON'S INN

OS Sheet 9, 108032
Bridge Street is the thoroughfare which runs from the town hall to
Harryville Bridge over the River Braid. Frank Dixon's inn was
located in this street.

On 7 June, at around 8 o'clock in the evening, James Dickey arrived on horseback with a sizeable contingent. He had been present at the Battle of Antrim that afternoon and had arrived to take command of the assembled insurgents. Some members of the provincial directorate of the United Irishmen also arrived at the same time. Dickey immediately established a Committee of Public Safety at Dixon's inn, whose brief was to impose order on the town. By now, upwards of ten thousand insurgents, including a large contingent from north Antrim, were present at Ballymena.

Early on 8 June, Dickey travelled to Connor, southeast of Ballymena, and personally executed Samuel Parker, a former colonel in the United Irishmen, whom he believed had passed information to the military at

Antrim warning them of the attack the previous day. Reports of the defeat at Antrim were now beginning to trickle into the town and the committee countered by announcing, falsely, that Carrickfergus Castle had fallen to the insurgents. A paralysis gripped the committee at a time when a firm lead was required and no initiative could be agreed as to the future action of the insurgent army.

The following day, 9 June, troops commanded by Colonel Clavering arrived at Ballee outside the town and offered clemency if the insurgents laid down their arms and immediately dispersed. About two hundred elected to join Henry Joy McCracken, whom they assumed was on Donegore Hill, but the remainder agreed to these unusually lenient terms.

James Dickey was captured by a party of the Sutherland Fencibles in a bog on Divis Mountain on 25 June. He was immediately transported to Belfast where he stood trial that afternoon on charges of treason and rebellion. He pleaded not guilty but the charges were upheld. Around eight o'clock in the evening he was hanged in front of the market house in Belfast, his head struck off and placed on a spike.

Frank Dixon was one of those wounded on 7 June as he attempted to surrender at the market house. The bullet entered his arm above the wrist and exited at the elbow. Dixon's yard was later used for the collection of weapons taken from the surrendered insurgents which were reported by Clavering to number one hundred and fifty muskets and eight hundred pikes.

BURIALS IN OLD GRAVEYARD, CHURCH STREET

OS Sheet 9, 109030
The graveyard is located approximately 250 m along Church
Street from the town hall. Normally locked, the key can be
obtained from the adjacent shop.

Following the murders of Davison and Crawford, their
bodies were taken to this graveyard and placed in an open
pit a few yards inside the entrance, on the left. The arms
of the dead men were placed around each other. (Robert
McCleery of Broughshane was later executed for taking
part in Davison's killing.) In 1825 the grave was dis-
covered but it was decided not to erect a monument as
the issue was still sensitive.

The old parish church here was built in 1721, but was
superseded in 1855 by St Patrick's church in Castle Street.
In 1798 the church was used as a barracks by the military
who broke up the furniture for firewood and generally
desecrated the building.

MILITARY CAMP AND SITE OF HANGINGS, BALLEE

OS Sheet 9, 105015
From the centre of Ballymena, take the B18 Toome Road for
approximately 500 m, then turn left into Carolhill Park.
Camphill primary school, adjacent to the wooded and partly
destroyed rath at the summit of the hill, is on the site of the
former military camp.

Around one o'clock in the afternoon of 9 June 1798,
Colonel Clavering arrived at Ballee, a mile to the south
of Ballymena, with the 64th Regiment of Infantry, some
of the Monaghan Militia and two pieces of artillery,
totalling five hundred men, and set up the camp which
gave the hill its name. He sent word into the town that
he would raze it if the remaining insurgents did not
immediately lay down their arms and disperse.

Clavering's terms were not extended to those who had
been involved in any atrocities and several United Irish-
men were to pay with their lives. The *Ordnance Survey
Memoirs* of the 1830s record that nine men were hanged

at the rath on Camp Hill, presumably during the time the military were encamped there. Of the nine, seven were Presbyterians and two were Catholics.

HARRYVILLE MOAT: SITE OF HANGINGS

OS Sheet 9, 113026
Harryville Moat is located 800 m from the town centre, on a
steep bank overlooking the River Braid, adjacent to the
A36 road to Larne.

The medieval motte and bailey earthwork here was the unusual setting for the execution of several United Irishmen. This prominent location on the main road south out of Ballymena served as a useful reminder of the continuing presence of the military in this disaffected area. The army were to stay for over a year at Ballymena, later occupying the race course at Broughshane as their headquarters.

The *Belfast News-Letter* records that, on 7 July, Charles and John Montgomery were executed at Ballymena following conviction on charges of treason and rebellion. Local history records that these two men, uncle and nephew, were hanged for their part in the assault on the Reverend William McCleverty of Crebilly House at Ballymena on 7 June 1798. The uncle was a farmer and the nephew a carpenter, both of Deerfin near Crebilly, and therefore knew their victim.

They were overheard talking about the assault by a third person, whose presence was unknown to them, when they took shelter from a rain shower while out cutting turf at Crebilly Bog. The informant, whose identity is not recorded, passed the information to the military who duly arrested the pair and made them stand trial for the offences. Following their conviction they were executed together at the moat.

Colonel Clavering, the military commander of the district, ordered the town to provide a hangman to carry out the execution or else pay a £50 fine. As the Montgomerys were well respected, the second option

was chosen. However, following the hangings the bodies were transferred to the market house in the town where Clavering further demanded that a person be found to cut off their heads and place them above the market house or else pay a £500 fine. As this fine proved too difficult to raise, the residents of the town took it in turn to solemnly hack at the dead bodies with a knife, so that no single person could later be accused of carrying out this barbarous act. Afterwards, the heads were hung from the tower of the market house.

Harryville Moat was to play a prominent part in the judicial affairs of the town for the next two years as the area continued to be disaffected. John Eagleson was hanged at the moat on 17 June 1799 for helping to flog Andrew Swan, his neighbour, on 24 April 1799. Swan later died of his injuries. Eagleson proclaimed his innocence at his trial but was nevertheless found guilty. Following execution his head was cut off and displayed on the market house. Another man named Robert McDonald was also found guilty of assisting in Swan's assault. McDonald received a sentence of transportation but he elected instead to serve in the Prussian army.

After the defeat of the United Irishmen in June 1798 many were unable to return to their former lives because of their prominent involvement in the Rebellion and instead became brigands. The most notorious gang in this area was led by a man named Thomas Archer, a former Antrim Militia soldier who had deserted to take part in the Rebellion. These circumstances combined to deny Archer the benefit of the amnesty offered to other participants.

Initially Archer's gang were popular outlaws, exacting revenge on loyalists in the district but, as time passed, their actions became less political and more criminal. The local population, which had initially been sympathetic, grew tired of their exploits and the net began to close in around them. During early 1800 the members of the gang were systematically brought to justice and executed. Andrew Stewart was hanged at Craigs, near

Ballymena, on 20 February. Two men named Dunn and Ryan were hanged at the moat on 24 February. (They were said to be strangers to the area, and were buried in the ditch beside the Kells road following their execution.) Roddy McCorley was hanged at Toome on 28 February, Caskey at Ahoghill on 3 March and Dr Lynn at Randalstown on 4 March.

For Archer, the end came when he was arrested whilst hiding in the Star Bog on the Ahoghill road. He was tried for his crimes and hanged at the moat on 10 March 1800. This was to prove the last time Harryville Moat was used for a public hanging.

KIRKINRIOLA GRAVEYARD

GRAVE OF WILLIAM ORR,
THE 'REBEL ORR'

OS Sheet 9, 115069
Take the A43 road from Ballymena to Cushendall. After passing under the motorway bridge on the edge of the town, take the second left into Bally Road. The cemetery is 0.75 km (0.5 miles) on the right, surrounded by a high stone wall. Enter via the lower gate and proceed 20 m to a high-railed enclosure containing two marble tablets mounted within a wall. One is dedicated to William Orr.

Orr's tablet is inscribed, 'Here rests the remains of William Orr who after various vicissitudes in early life resided for many years at New Grove where he died in the enjoyment of the peace of God December 25th 1860 aged 68.'

William Orr was a United Irishman and a cousin of the William Orr who was executed at Carrickfergus in October 1797 for administering an illegal oath (see p. 108). The William Orr buried here was known as the 'Rebel Orr' to distinguish him from his cousin. He took part in the Rebellion in 1798 and, as a result, was transported to Botany Bay for a period of years. On his return he settled at New Grove, Ballygarvey, until the end of his life.

THE ARDS PENINSULA

The area south from Bangor to Portaferry is known as the Ards Peninsula and is rich in the folklore of the 1798 Rebellion. Today the peninsula remains much as it was then: a patchwork of modest sized, mixed agriculture farms served by a network of regularly spaced villages down its 40-km (25-mile) length. Then, as now, except for the area surrounding Portaferry in the south, the population was predominantly Presbyterian.

BANGOR ABBEY

YEOMANRY DRUM, LOYALIST AND INSURGENT GRAVES

OS Sheet 15, 501811
The abbey church is located at the junction of Abbey Street and the Newtownards Road, about 300 m west of the town hall. The graveyard is open during normal office hours. The church is usually open from 9.30 a.m. to 11.30 a.m., Monday to Saturday, all year.

DRUM OF THE RATHGAEL YEOMANRY INFANTRY

Hanging in the vestibule of the church is the drum of the Rathgael Yeomanry Infantry, a unit raised by James Dowsett Rose-Cleland of Rathgael, an important local landlord whose country residence was formerly located 1.5 km (1 mile) south on the road to Newtownards. The yeomanry unit was composed mostly of the Orange tenantry on the estate and Cleland paid for its upkeep at his own expense.

First raised in November 1796, yeomanry units carried out garrison and policing duties which relieved regular troops for other tasks. Yeomanry units consisted of both infantry and cavalry and officers were appointed by government who controlled and partly financed the regiments from Dublin Castle. After the Rebellion of 1798

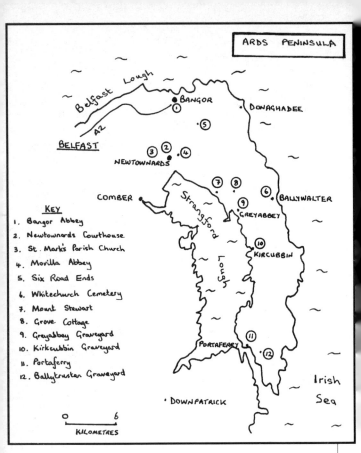

ARDS PENINSULA

KEY

1. Bangor Abbey
2. Newtownards Courthouse
3. St. Mark's Parish Church
4. Movilla Abbey
5. Six Road Ends
6. Whitechurch Cemetery
7. Mount Stewart
8. Grove Cottage
9. Greyabbey Graveyard
10. Kircubbin Graveyard
11. Portaferry
12. Ballytrustan Graveyard

0 6
KILOMETRES

many units were stood down and did not reappear. However, following the outbreak of hostilities again with France in 1803, some were re-formed and served until the end of the Napoleonic War in 1815. On the underside of the drum the names of Saintfield and Ballynahinch have been inscribed and tradition holds that the unit fought at both battles. The report of the Battle of Saintfield in the *Belfast News-Letter* mentions that yeomanry from Newtownards and Comber were involved.

GRAVE OF JAMES DOWSETT ROSE–CLELAND

From the west door, go 15 m north towards the perimeter

wall. The Rose-Cleland monument is of polished black marble, one of several belonging to the Cleland family. As noted above, James Dowsett Rose-Cleland was a landlord who lived at Rathgael House, about a mile (1.5 km) south of here on the Newtownards Road. He was actively involved with the Orange movement and is credited with forming the Yeoman Infantry unit whose drum hangs in the foyer of the church. He is said to have recruited this unit exclusively from his own tenants which, in this area of north Down, would suggest some, at least, were Presbyterian.

The *Belfast News-Letter* records in its edition of 12 June 1798 that the Newtownards and Comber yeomanry, composed of cavalry and infantry and commanded by Captains Houghton and Cleland, acted with 'the greatest intrepidity' during the action at Saintfield on 9 June.

The cannon in the car park beside the graveyard is from the Ulster privateer *Amazon*, wrecked in Ballyholme Bay on 23 February 1780 with the loss of all hands. (It was commanded by Captain George Colvill, whose grave was formerly located in the graveyard.) The cannon was subsequently salvaged by Rose-Cleland who placed it outside his home at Rathgael. In 1803, Rose-Cleland was a member of the jury which convicted Thomas Russell of treason (see p. 160). Cleland's political career included his appointment as lord lieutenant for County Down before he died in 1852 aged eighty-five.

GRAVE OF JAMES DUNLAP

About 10 m from the west door of the abbey is the grave of a Lightbody. James Dunlap's grave is directly over the wall behind, in the old section of the graveyard. It consists of a low set altar tomb, beside the more prominent grave of Mary Dunlap, possibly a relative.

James Dunlap was one of numerous men from the Bangor area who was involved in the Rebellion and paid a high price. Following a military court martial at

Newtownards market-house he was found guilty of treason and rebellion and sentenced to death by hanging. The *Belfast News-Letter* correctly reports that James Dunlap, Thomas McKnight and Robert Robinson were all hanged on Tuesday 10 July 1798, although a date of 24 July is given on the gravestone (see also p. 134). As with most hanged insurgents, their names only appear on the headstone many years later, in this case almost thirty years, when the Rebellion had become less politically sensitive.

GRAVE OF ARCHIBEL WILSON

The slate headstone is located approximately 25 m from the south transept gable of the abbey church.

Archibel Wilson, a carpenter from Conlig, County Down, was hanged at Bangor pier with two others on 26 June 1798 for his alleged involvement in the Rebellion. Wilson had argued his innocence at his trial and went to the gallows on his bare knees, singing psalms. A twelve-line epitaph on his headstone continues his claim:

> Morn not, dear frends, tho I'm no more
> Tho I was martred, your eyes before
> I am not dead, but do sleep hear
> And yet once more I will appeer.
> That is when time will be no more
> When thel be judged who falsely sore
> And them that judged will judged be
> Whither just or onjust, then thel see.
> Purpere, deer frends, for that grate day
> When death dis sumance you away
> I will await you all with due care
> In heven with joy to meet you there.

However local tradition relates that Wilson was not hanged at Bangor but at Conlig, on a hill above the village. The *Belfast News-Letter* account would go some way to support this as it states in the Friday 29 June edition: 'Tuesday last [26 June] Archibald Wilson, mason, was executed at Conlig, between Newtownards and

Bangor, having been found guilty by court martial of rebellion and treason'.

GRAVE OF ELIZABETH TEMPLETON

Some 30 m from the east window, just beyond a large old holly tree, is the slightly sunken slate headstone of Elizabeth Templeton. This woman, known to her contemporaries as Eliza, was the sister of the eminent botanist John Templeton, whose family home was at Orange Grove (now Cranmore), Belfast. She was a close friend of Mary Ann, sister of Henry Joy McCracken, and a frequent correspondent to Henry Joy during his confinement at Kilmainham. It would appear that she was his secret admirer although McCracken, unfortunately, seems to have shown no great affection for her. She remained unmarried, living out her later life in Bangor.

NEWTOWNARDS COURT-HOUSE

SITE OF SKIRMISH ON 10 JUNE 1798

OS Sheet 15, 490741
The court-house here, formerly a market house, sits on the north side of Conway Square, in the town centre.

Early on 10 June, a large body of United Irishmen from the lower Ards barony, armed mostly with farm utensils, attacked the small military garrison of Yorkshire Fencibles in the court-house from the direction of North Street. Corporal William Sparks of the Yorkshire Fencibles, who was part of the garrison, was later to testify that the insurgents were led by Sam Rankin of Newtownards and William Davidson of Greenwell Street. Rankin was armed with a sword and Davidson carried a pike.

The insurgents were beaten off by a fusillade of small-arms fire and suffered several casualties before retiring to wait for reinforcements. Later in the afternoon, they were met by contingents from Bangor and

Holywood and they returned to renew their attack. However, the government forces had already evacuated the town and the United Irishmen passed through it to spend the night on Scrabo Hill before setting off the following morning for Saintfield. The town hall contains a small cell, reputedly in existence at the time of the Rebellion. It is located through a modern door immediately to the right of the main entrance. It has an unusual steep corbelled roof and a small window along one side, containing bars. The cell undoubtedly saw much activity, for throughout the summer of 1798 the market house was used both as a gaol to house prisoners and as the place where the military courts martial were heard. Three Presbyterian ministers, James Porter of Greyabbey, Robert Gowdie of Dunover and Archibald Warwick of Kircubbin, were each found guilty here of treason and Rebellion, and executed. Elsewhere in Ulster other ministers were to be implicated in the Rebellion, some on much more serious charges, but these three were the only ones to pay with their lives.

However, capital punishment was not the only sentence handed down. Alexander Clandening of Newtownards was sentenced to life transportation following his trial. John Quinn, Dr Wilson and James McKittrick all received fourteen years' transportation. Adam Mullen of Cardy received five hundred lashes. Andrew Orr received the same sentence as Mullen but opted for military service abroad for life.

An unusual incident was reported by the *Belfast News-Letter* in its Tuesday 31 July edition. During the previous week, a prisoner had fallen from an upper window of the market house and had died instantly. No other details surrounding the incident were reported.

ST MARK'S PARISH CHURCH, NEWTOWNARDS

MEMORIAL TO LORD CASTLEREAGH

OS Sheet 15, 485743

St Mark's parish church is located approximately 500 m west of the courthouse in Church Street (continuance of Regent Street) at the corner of Frederick Street. The Londonderry family memorials are situated above the altar in the east end of the church. There are several memorials to the Stewart family here, including one to Robert Stewart, first Marquess of Londonderry, and to his son, also Robert Stewart, second Marquess of Londonderry, better known to history as Lord Castlereagh.

Robert Henry Stewart is one of the most important Ulster politicians to have served in a British administration. He held several posts in the British government between 1802 and his early death in 1822, but it is his earlier involvement in the Dublin administration of his uncle Lord Camden, the then lord lieutenant of Ireland, which earned him his notoriety. As Camden's chief secretary in 1798, he had been closely associated with the brutal suppression of the Rebellion and the consequent Act of Union in 1801 which resulted in the abolition of the Irish parliament.

The Stewart family in many ways typifies the changes which took place among some wealthy Presbyterian families in Ulster during the eighteenth century. At the beginning of the period they were sizeable landowners without political power, but as the century progressed they became one of Ireland's more influential and important aristocratic families.

Alexander Stewart, Castlereagh's grandfather, was born at Ballylawn near Manorcunningham, County Donegal, on lands originally granted by James I. He later acquired an estate in the Ards peninsula which became the family home, Mount Stewart. As the century continued the family were to enjoy increasing wealth and influence as the Presbyterian community in general

became freed from the earlier restrictive Penal Laws. Though Castlereagh's father was a natural Whig, he was raised to the peerage as Earl of Londonderry in 1796 (hence the younger Robert's courtesy title of Viscount Castlereagh) and later Marquess in 1816. Castlereagh, although born a Presbyterian, converted to the Anglican faith as part of his requirement for entry to university.

Thus by the 1790s the Londonderry family, along with other Presbyterians, were finding that the future was a choice between agitating for further immediate reform, resulting in possible confrontation with government, or consolidating their hard-won liberties and working within the system to effect further change.

MOVILLA ABBEY, NEWTOWNARDS

INSURGENT GRAVES

OS Sheet 15, 504743
From Newtownards town centre, take the A48 road east for Donaghadee. After approximately 0.75 km (0.5 miles), the road rises steeply up a hill out of the town. Halfway up this hill, take the fork to the right, signposted for the cemetery. The ruins of the old abbey are visible on the right.

On 10 June 1798 this graveyard was chosen as the assembly point for local insurgents prior to their attack on the garrison in Newtownards. According to a narrative purportedly written by a William Fox (but in fact David Bailie Warden), about three hundred men armed with guns and pikes assembled here before setting off in two columns to attack the military in the market house.

ARCHIBALD WARWICK'S GRAVE

From the main entrance to the cemetery, veering left, proceed to the conspicuous Greek temple mausoleum of the Corry family. Warwick's grave is 10 m away towards the trees on the perimeter.

Archibald Warwick was a licentiate of the Presbyterian

church who, according to some sources, lived at Drumawhey near Six Road Ends, outside Bangor. He was licensed on 5 September 1797 and commenced preaching at Kirkcubbin (sic) Presbyterian church under the supervision of the Reverend George Brydone. On 18 July his name appeared in a list of 'leaders and principal agitators' for whom a reward of fifty guineas was recoverable for their apprehension. On 14 August 1798 his name also appeared on a list of suspects forwarded by General Nugent to Dublin Castle following his arrest for treason and rebellion. His trial took place at Newtownards the following morning.

The evidence against him was contradictory. One witness alleged that on 10 June he had been instructed by Warwick to collect the insurgents at Ballymullan and bring them in. Another witness swore that on 10 June the prisoner had instructed him to travel from Kircubbin to Inishargy to rally the insurgents there. Another, William Harvey, an excise officer, stated he had seen Warwick in Greyabbey on 11 June, armed with pistols, and had also seen him the following evening in front of a body of armed men, with a pistol in his hand. However, other witnesses swore Warwick had met a party of armed men on the road near Kircubbin who had forced him to join them on pain of death.

Despite this, Warwick was found guilty and sentenced to death. In mid-August, the *Belfast News-Letter* carried a report that several persons had recently received death sentences following courts martial at Downpatrick, but that these were not to take place until approval had been received from Dublin. From this it was understood that further executions as a result of the Rebellion were now unlikely. Warwick's sentence would have fallen into this category.

However, he was to remain in Newtownards gaol for a further two months before being suddenly taken to Kircubbin and hanged on the Green in front of his church on 15 October 1798. Local tradition remembers Warwick's hanging with anger and sorrow. Many believe

Castlereagh prevented any clemency for the prisoner and was instrumental in seeing that capital punishment was carried out in this case.

ROBERT ROBINSON'S GRAVE

Robinson's grave is located 10 m south of the west gable of the old abbey ruins, in a low railed enclosure containing four headstones.

Robert Robinson, of Ballygrainey, near Six Road Ends, is listed as being hanged at Newtownards following a court martial on 10 July 1798. He was only twenty-two years old. He is buried here in a family grave with several others, one of whom, Samuel, appears to be an older brother who did not actively participate in the Rebellion. In the *Belfast News-Letter* of 17 July, Robinson's execution for treason and rebellion is recorded along with James Dunlap and Thomas McKnight.

MARGARET CALDOW'S GRAVE

An upright sandstone marker directly behind the Robinson plot marks the grave of Margaret Caldow, who died on 19 January 1798, aged twenty-four. Her husband was John Caldow, captain and adjutant of the Yorkshire Fencible Regiment, presumably stationed in the town. The two-line epithet, partly submerged, reads:

Go home dear friends and shed no tears
I must lie here till Christ appears.

Fencible regiments were raised in Britain and Ireland in 1793 as a response to the war with France declared in February of that year. Units could consist of cavalry or infantry but in Ireland those involved in the 1798 Rebellion were exclusively infantry. They were defined as regular troops but were not liable to serve overseas. Most were disbanded by 1801; some were to volunteer for postings abroad.

The Yorkshire Fencibles were an infantry regiment

involved in General Lake's disarming of Ulster in 1797. They subsequently fought at both Saintfield and Ballynahinch, and sustained numerous casualties during the former encounter.

SIX ROAD ENDS

BETSY GRAY'S COTTAGE

OS Sheet 15, 532775
The hamlet of Six Road Ends is approximately 6.5 km (4 miles) from Newtownards on the A48 to Donaghadee. At the Six Road Ends junction, turn right along the Upper Gransha Road towards Carrowdore for about 600 m. On the right is Summerhill Private Retirement Home, with a farmyard attached. The ruined cottage, is about 100 m down a lane from the farmyard. Seek permission from Summerhill to proceed.

Elizabeth (Betsy) Gray was a young and, by many accounts, very pretty girl, who accompanied her brother George and sweetheart, Willie Boal, on the ill-fated march of the north Down United Irishmen to the assembly at Creevy Rocks and on to the eventual defeat at Ballynahinch. Her undying fame is in large part due to the novel written by W.G. Lyttle in the 1890s entitled *Betsy Gray or Hearts of Down* which is set in the Six Road Ends area and follows the fate of the three young people in the Rebellion.

However controversy has ensued as to her origins and the real truth about Betsy Gray may never be fully resolved. Strong evidence argues that she lived at Six Road Ends with her widowed father and her brother, George, but another theory places her home at Garvaghy near Waringstown in the west of the county. Given the strength of popular local lore regarding her and given that most of the insurgents came from the north and east of the county, it is likely that Six Road Ends has the stronger case. Today, though, it is difficult to gauge how much Lyttle's book has influenced local tradition.

Contemporary accounts of her do exist, though again the details are sometimes contradictory. In his *History of the Irish Rebellion of 1798* Charles Hamilton Teeling, writing in the 1830s, confirms that a girl named Betsy Gray followed her brother and another man from the Ards to Ballynahinch but also states that it was her mother who was widowed. A poem written in 1810 by a Miss Balfour confirms the events surrounding the deaths of the three young people after the Battle of Ballynahinch.

Although many women were similarly caught up in the events of the rebellion, two factors have ensured that Betsy Gray's story is still fondly remembered. Firstly she was famed for her appearance, described as 'the perfection of female beauty'. The second was the barbaric manner of her death (see pp. 170–1 and 172–3).

The cottage is interesting in itself as it contains many original eighteenth-century features. However it is in poor condition and needs massive restoration now or it will be lost for ever.

WHITECHURCH CEMETERY, BALLYWALTER

INSURGENT GRAVES

OS Sheets 21/15, 622699
From the centre of Ballywalter village, take the road north for Millisle (A2) before turning left into Dunover Road on the outskirts of the town. The cemetery is about 600 m along the road to the right and is signposted.

MAXWELL BROTHERS' GRAVESTONE

This headstone is a large raised horizontal slab with a cracked top, located just beyond the south-west corner of the ruined church. The stone is dedicated to Hugh and David Maxwell from Ballywalter who were both killed in the skirmish at Newtownards on 10 June. It reads:

Lo Erin's genius hov'ring o'er the tomb
With mournful eye surveys the hallow'd sod
Where sleep her bravest sons in earth's dark
 womb
Tears fall, hope whispers 'cease, they dwell with
 God'.

JAMES KAIN'S HEADSTONE

Approximately 6 m from the ruined west gable of the church and 10 m from the Maxwell grave is the tall and ornately carved slate stone of another insurgent. Though the main name on the top reads 'James Kane, Ballywalter', it is also spelt Kain further down. As with the Maxwell brothers, James Kain was killed taking part, with other United Irishmen from the Lower Ards area, in the attack on Newtownards market house on 10 June .

The *Freeman's Journal* of 11 August 1798 records that, 'Of the little village of Ballywalter in the Ardes, nine men were actually killed and thirteen returned wounded, victims of their folly. If a trifling village suffered so much, what must have been the aggregate loss in those parts of the country which were in a state of rebellion?'

The relative remoteness of this area of the Ards peninsula may explain why the headstones were able to carry their open and triumphant message relating to the events of 1798, whereas stones in other areas only record the names of those killed or hanged many years later.

MOUNT STEWART

HOME OF ROBERT STEWART,
LORD CASTLEREAGH

OS Sheets 15/21, 552697
Mount Stewart estate is situated about 8 km (5 miles) from
Newtownards on the Greyabbey road (A20). It is owned by the
National Trust and is open between Easter and September during
office hours, though it is worth confirming this before visiting the
house (tel. 012477 88387).

The large estate at Mount Stewart was acquired by
Alexander Stewart in 1744 and became the family home
for the next two centuries. Robert Henry Stewart,
second Marquess of Londonderry (1769–1822), generally
known by the courtesy title of Lord Castlereagh, is the
most famous family member. Born at 28 Henry Street,
Dublin, he was brought up at Mount Stewart and edu-
cated at Armagh Royal School and St John's College,
Cambridge. In August 1786 he almost drowned in
Strangford Lough when his boat overturned in a squall.

In 1790 he was elected MP for County Down on a
reforming ticket but despite this, he was to develop his
political career in the administration of his uncle, Lord
Camden, who became lord lieutenant of Ireland in 1795.
Castlereagh became his chief secretary and it was this
close association with government during the 1798
Rebellion and after which earned him the reputation of
'bloody'. In many contemporary accounts he is person-
ally accused of condoning the excesses committed by
the military in the suppression of hostilities and the con-
sequent trials of suspected persons involved. However,
the reputation was in part misplaced as he was appalled
by the atrocities and was to intervene to terminate the
gross practices. He was instrumental in steering the Act
of Union through parliament, which abolished the Irish
Houses of Parliament and placed the island under the
political control of the British government at

Westminster in 1801.

From 1802 to his untimely death in 1822 he was to hold major ministerial positions and was Britain's chief negotiator at the 1814 Congress of Vienna, which settled the boundaries of European states for the rest of the century. He committed suicide in August 1822 by cutting his throat with a pen-knife at Cray Farm, his country residence in Kent. He was buried in Westminster Abbey.

Mount Stewart house and estate are good examples, in Ireland, of the kind of late-Georgian aristocratic style so despised in France by the Jacobin revolutionaries. Much of the house pre-dates the Rebellion and there are numerous artefacts and items associated with Lord Castlereagh's extensive political career which are worth seeing in order to build up one's own picture of this controversial figure from Irish history.

GROVE COTTAGE

BALLYBOLEY

OS Sheets 15/21, 575703
The cottage is located on Ballyboley Road, a minor road from
Greyabbey to Carrowdore, approximately 2.5 km (1.5 miles)
from Greyabbey.

In this cottage, in 1798, lived a widow named Sarah Byers and her two grown-up sons, Alexander and William, both of whom, according to local tradition, were involved in the United Irish movement. When called to arms at the beginning of the Rebellion, the brothers allegedly drew lots to see who would stay at home and look after their elderly mother, then aged eighty-six. Alexander won the right to accompany his local regiment to Ballynahinch where he was killed (see p. 141).

The house was altered in the 1940s by having the existing walls raised by 60 cm and dormer windows inserted in the roof-line. However the fine sandstone doorway of the original house remains behind a recently erected

conservatory. It is a good rural indication of the contemporary economic wealth of this predominantly Presbyterian district.

GREYABBEY GRAVEYARD

GRAVES OF THE REVEREND
JAMES PORTER AND ALEXANDER BYERS

OS Sheets 15/21, 583682
From the main street in Greyabbey, the old abbey is about
100 m along the B5 to Ballywalter. The graveyard is located
beside the abbey.

GRAVE OF THE REVEREND JAMES PORTER

Through the main entrance to the graveyard, James Porter's grave is about 10 m short of the north-east corner of the ruined abbey gable ahead. It is marked by a large raised horizontal tablet.

James Porter was born in Tamna, near Ballindrait, County Donegal, in 1753. His parents were both Presbyterian and he entered the ministry at Greyabbey in 1787 following an education in Glasgow. He is also said to have been a great classical scholar.

He espoused the twin beliefs of emancipation and reform of government in Ireland, and promoted the cause of the United Irishmen with lecture tours. Some accounts claim he took the oath of the United Irishmen although others say he refused to be a member because it clashed with his clerical function. Nevertheless, he wrote seditious attacks in the *Northern Star*, exposing political espionage in the area under the title of 'Billy Bluff and Squire Firebrand', thought to satirise Lord Londonderry, the local magnate, and the Reverend Montgomery of Rosemount.

After the failed insurrection, he was arrested and charged at Newtownards with having intercepted a military despatch from Belfast between 11 and 13 June

1798. Though the messenger from whom the despatch was taken could not identify Porter, he was condemned by another witness who claimed to have been involved in the incident. Despite pleas of clemency from his wife to Lady Londonderry, his earlier writings about the aristocrat ensured that support from that quarter was denied. Porter was hanged outside his own church in Greyabbey on 2 July 1798.

GRAVE OF ALEXANDER BYERS

From the entrance, the grave, a raised horizontal slate slab, is 25 m to the left near the wall. Alexander Byers of Grove Cottage, Ballyboley (see p. 139–40), was killed in the fighting at Ballynahinch on 13 June and is buried here with other family members. His brother William was also a United Irishman but stayed at home with his widowed mother and consequently survived to old age. Most fallen insurgents ended up in a mass grave at Ballynahinch and Byers was one of the few to have been brought home for burial.

Also buried in the graveyard is William Patton, father of John Patton, who wrote home regarding his situation as an insurgent at Saintfield on 11 June 1798, just prior to the advance of the United Irishmen on Ballynahinch. His letter is preserved in the Public Record Office of Northern Ireland and represents one of the few insurgent documents of the time.

KIRKCUBBIN GRAVEYARD

GRAVE OF THE REVEREND GEORGE BRYDONE AND SITE OF ARCHIBALD WARWICK'S HANGING

OS Sheet 21, 596627
From Greyabbey take the A2 road to Kircubbin. In the centre of the village is a large open area known as the Green. The Presbyterian church and graveyard are on the seaward side of this open space. Brydone's grave, a low box tomb, is located 6 m south of the middle window of the church.

This church was originally part of Ballyhalbert congregation. In 1777 the villagers asked for their own church from the Synod of Ulster but were refused. They went ahead anyway, calling George Brydone, a minister ordained by the Scottish Presbytery of Lauder, in April 1778. His appointment to Kirkcubbin (sic) Presbyterian church was initially resisted by the synod because of his Scottish background. He was the minister at the time of the 1798 Rebellion and was present at the hanging (on the Green in front of the church) of Archibald Warwick, a young licenciate who worked alongside him (see pp. 132–4).

PORTAFERRY

SITE OF SKIRMISH AND THE REVEREND WILLIAM STEELE DICKSON'S CHURCH

OS Sheet 21, 594509
The village of Portaferry lies at the southern end of the Ards peninsula at the narrow entrance to Strangford Lough. From Greyabbey, take the A20 road signposted for Portaferry, a journey of 18 km (11 miles).

GRAVE OF JAMES MAXEWELL, BALLYPHILIP GRAVEYARD (TEMPLECRANNY)

Located towards the end of Church Street, at the entrance of the town, and surrounded by a high stone wall, is the ancient parish church of Ballyphilip, or Templecranny, dismantled in 1787 for a new church nearby. The gates are usually locked but access to the graveyard can be arranged through Ards Borough Council, who manage the site. Proceed for 10 m up the gravel path and then turn right for 5 m. Maxewell's grave is a tall, well-carved, slate headstone. James Maxewell is recorded as having died on 10 June 1798, aged twenty-nine. Though there is no conclusive proof, it is probable that he died in the engagement in the town.

The church here suffered directly from the hands of

Viscount Castlereagh, though long before he became a lord. Robert Stewart was a pupil of the Reverend Mr Storrocks of Portaferry in the 1780s. Together with a fellow pupil he obtained gunpowder and, as an idle prank, blew up the ancient church.

SKIRMISH AT THE MARKET HOUSE, 10 JUNE 1798

The market house, dating from 1769, is located in the main square of the village. On 10 June 1798 a large body of insurgents from the Upper Ards area, armed mostly with farm utensils, descended on the town and its small yeomanry garrison. They charged *en masse* up Church Street intending to overwhelm the garrison in the market house and from there to pass over the narrow straits to threaten the garrison at Downpatrick from the rear. However, the yeomanry commander, Captain Mathews, had taken the precaution of building walls between the arches of the lower storey of the market house to make the building fire-proof and barricaded his small garrison in the relative security of the upper floor. As a consequence, the insurgent attack was broken up by the accurate musketry of the yeomen, aided by cannon fire from a revenue ship commanded by a Captain Hopkins, anchored in the narrows, which was able to direct grape-shot up the narrow streets. The insurgents were forced to retire from the village having suffered some casualties (the *Belfast News-Letter* reports that forty were killed but this is likely to be an exaggeration). Despite his victory, Mathews expected further assaults and so decided to evacuate his garrison across the straits to Strangford. The defeated insurgents fled back northwards to Inishargie, where they set up a camp, but remained inactive for the remainder of the Rebellion.

The village retains much of the character of its late-eighteenth-century past and it is easy to envisage the insurgent thrust along the narrow confines of Church Street and the reply from the yeomanry sited in the extant market house.

PORTAFERRY PRESBYTERIAN CHURCH

The church is located 50 m down Steele Dickson Avenue off High Street. The church here is associated with the Reverend William Steele Dickson, who became its minister in 1790, although the present building dates from the early nineteenth century. He was heavily involved in the United Irish movement and, after the arrest of Thomas Russell in 1796, became the adjutant-general for County Down. However he was arrested on 5 June, immediately prior to the planned uprising, and thus took no part in the subsequent events (see pp. 60–2). He was to remain in gaol until 1802.

For Dickson the ultimate insult was to take place on 1 July 1798 when his congregation held a meeting in the church to publicly thank Captain Mathews and the yeomanry for their 'spirited and steady conduct in defending the town of Portaferry and repulsing the rebels on Sunday 10th June last'. Despite this understandable volte-face, the congregation were to leave the pulpit vacant for Dickson for several years, pending his release. He did not, however, return to Portaferry.

The church found here today is a fine large edifice, built in the classical style which the Presbyterians so preferred in the early nineteenth century. From the church, proceed on up Windmill Hill to the viewpoint. From here it is possible to see the site of the skirmish below and the narrows across to Strangford. It is likely that Mathews would have posted look-outs on this hill as the approach of the insurgents would have been clearly visible from here.

BALLYTRUSTAN GRAVEYARD

GRAVE OF EDWARD SMYTH

OS Sheet 21, 612498
From Windmill Hill continue to the end of the road. Turn left and
immediately right on to Ballyfounder Road. After 1.2 km
(0.75 miles) a stone gate and stile are reached on the left. Cross the
stile and, 100 m across the field, find the stone enclosure of
Ballytrustan graveyard. From the gateway, walk approximately
40 m, aiming for midway along the very overgrown remnants of
the church. Smyth's grave, a well-cut slate stone, is close to the
outside north wall, in thick undergrowth.

The headstone here informs us that Edward Smyth was
a sergeant in the Portaferry Yeomanry who died on
28 May 1801, aged forty-six, 'having acted the part of a
good subject and soldier'. Presumably Smyth was one of
the Portaferry Yeomanry who was involved in the skirm-
ish at Portaferry on 10 June and managed to survive due
to Captain Mathews's foresight in barricading the market
house. His grave is significant as loyalist graves, particu-
larly those of the yeomanry, are very rare and this one
represents the only one the author can find of a non-
commissioned officer on the government side. Most
yeomanry units were stood down from duties at the
conclusion of the Rebellion.

EAST DOWN I

This tour covers the first phase of the Rebellion in County Down up to the Battle of Saintfield and includes other sites close to the western shore of Strangford Lough. Beginning at Comber the reader has the choice at Saintfield of continuing the tour as detailed, or to continue into East Down II and the events surrounding the next stage of the Rebellion.

COMBER PARISH CHURCH

MEMORIAL TO THE
YORKSHIRE FENCIBLES

OS Sheets 21/15, 461693
The church is located on the east side of the town square. The memorial is inside the building on the south wall. The church is usually open.

The memorial is dedicated to three officers of the Yorkshire Fencible Infantry who fell during the Battle of Saintfield. The three were Captain William Chetwynd, Lieutenant William Unite and Ensign James Sparks. It is believed Chetwynd commanded the Light Company which was in the van of the column and subsequently suffered heavy casualties in the fighting. Daniel Millin, a farmer from Tonaghmore, County Down, allegedly shot Chetwynd during the battle as he was attempting to rally his troops. Millin was to claim remorse for his deed for the rest of his life.

This memorial is the only one in the province which is dedicated to the regular government troops who fought in the Rebellion of 1798.

TULLYNAKILL GRAVEYARD

GRAVE OF JOHN McWILLIAMS

OS Sheet 21, 502645
From Comber town square, take the A22 south for Killyleagh. At
Lisbane hamlet, turn left onto the Ballydrain Road. Proceed
2.5 km (1.5 miles) to a crossroads and turn right. Tullynakill
graveyard is approximately 1.5 km (1 mile) on the left. Go through
the arched entrance. McWilliams's upright sandstone marker with
masonic symbol is the third monument on the left.

This grave, erected by James McWilliam (sic) of

Lisbarnet, contains the remains of his son, John, who was killed at the Battle of Ballynahinch on 13 June 1798. He was twenty-one years of age. A local story relates that his mother, Mary (also commemorated on this stone), identified and brought back his body by horse and cart to be buried in his home parish. As with many other graves, his death was only recorded on the gravestone many years after the event.

KILLINCHY PARISH CHURCH

INSURGENT GRAVES

OS Sheet 21, 508608
From Lisbane hamlet, continue south for 4 km (2.5 miles) to
Balloo crossroads. Turn left and proceed for 1 km (0.75 miles) to
Killinchy village. There, take the Church Hill Road to the small
white parish church on the hill.

GRAVE OF DR JAMES CORD

The gravestone of well-cut slate is at the rear of the graveyard approximately 10 m from the west gable. Dr James Cord (or Chorde) was tried at Downpatrick on 21 June 1798, charged with treasonable practices in encouraging the inhabitants of Killinchy to rebel and with having a command in the insurgent army at Saintfield and Ballynahinch. Following a lengthy trial, he was found guilty 'on the fullest and clearest evidence' and was hanged on 23 June 1798. During the trial it was claimed that he was the principal leader of the insurgents at the Battle of Saintfield on 9 June. If the claim is true, then Cord must have been instrumental in withdrawing the Killinchy men from Ballynahinch on 13 June following disagreement with Monro's battle plan (see pp. 164–9).

Cord was one of several professional men, including a Dr Jackson of Newtownards, who were involved in the County Down events.

Note the superb panoramic views towards Strangford

Lough and inland over the rolling countryside of County Down.

GRAVE OF JAMES McCANN

Below a large yew tree, 25 m south of Cord's grave, is the recumbent slate headstone to James McCann, laid in front of the upright stone memorial to McCann of Belfast. The faint lettering reads: 'Erected by John McCann of Carragullin in memory of his father James McCann who departed thi[s life] the [] June 1798. Aged 44 [years]. Also his mother Jane Carse who died 11th [] 73 years.'

The *Belfast News-Letter* records the court martial of 'James McCan of Killinchey' in its 29 June edition. He was charged with having forced persons into a rebellion and having the appearance of a leader. The charges being fully proved by the court, he was hanged on 27 June 1798.

SAINTFIELD

BATTLE SITE AND INSURGENT GRAVES
AND WEAPONS

OS Sheet 21, 406591
Return to Balloo crossroads and take the road to Saintfield. Park in Main Street near the First Presbyterian church.

THE BATTLE OF SAINTFIELD: 9 JUNE 1798

On Saturday 9 June 1798 a fiercely contested encounter took place here between government troops and the army of the United Irishmen. This battle was unique in the Ulster Rebellion for it was the only occasion in which the United Irishmen could claim some success against regular troops in the field. The sequence of events which led to the battle began the previous evening.

In accordance with the planned rising, insurgents began to assemble on Ouley Hill, two miles (3 km) north of Saintfield, on the evening of 8 June. These men came

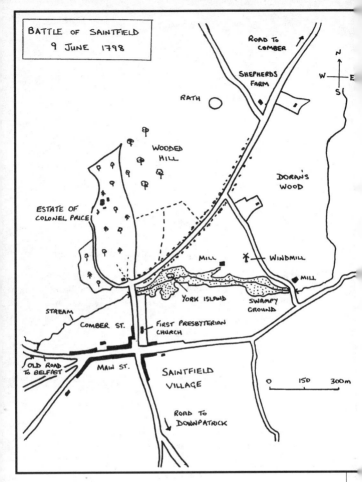

BATTLE OF SAINTFIELD
9 JUNE 1798

ROAD TO COMBER

SHEPHERDS FARM

RATH

WOODED HILL

DORAN'S WOOD

ESTATE OF COLONEL PRICE

MILL

WINDMILL

MILL

YORK ISLAND

SWAMPY GROUND

STREAM

COMBER ST.

FIRST PRESBYTERIAN CHURCH

OLD ROAD TO BELFAST

MAIN ST.

SAINTFIELD VILLAGE

ROAD TO DOWNPATRICK

0 150 300m

from Saintfield, Killinchy, Lisbane and the intervening areas and by morning perhaps three thousand had assembled. However, it was soon clear that much of the leadership had failed to turn out with them. During the morning this armed assembly moved into Saintfield and occupied it. 'Colonel' Richard Frazer of Ravarra, County Down, and a man named McKinstry were found to lead this army and these two men now began the unenviable task of organising their troops into some sort of coherent fighting force.

Meanwhile at Newtownards, the garrison comman-
der, Colonel Chetwynd Stapleton, had been informed
of the rising at Saintfield and set off early on 9 June with
a strong force to nip the Rebellion in the bud. These
troops consisted of two hundred and seventy of the York-
shire Fencible Infantry, a corps of yeomen cavalry and one
of infantry from Comber and Newtownards, together
with two six-pounder cannon, manned by regular artil-
lery personnel. A number of civilian volunteers also
accompanied the column, including the Reverend
Robert Mortimer, rector of Portaferry. In total,
Stapleton's column numbered around four hundred
troops. It is 19 km (12 miles) from Newtownards to
Saintfield. It was therefore late afternoon before Staple-
ton's column reached the village and his approach was
observed by insurgents perched on the surrounding hills.

In 1798, Saintfield consisted of a single built-up street
(Main Street) stretching between the Presbyterian church
and the parish church. Then, as now, this street was
bisected by the road leading north to Comber (modern
Comber Street) and south to Downpatrick. The road to
Belfast at that time entered the village a mile to the west –
the present A7 did not exist. From the Presbyterian
church the Comber Road ran northwards for about
200 m to the entrance of the Price estate, crossing a small
stream which flowed sluggishly through swampy
ground. The road then swung north-east and, passing
between thick hedges, reached Jack Shepherd's farm
about 0.75 km (0.5 miles) away near the junction with
the present-day A7. Travelling out from Saintfield, the
ground to the north rose steeply to a wooded convex
summit while on the right the ground fell away to the
swampy bottom containing the stream and a wooded
copse known as Doran's Wood.

The musketeers amongst the United Irishmen
positioned themselves behind the thick hedges on the
road. The main body of pikemen under McKinstry and
Frazer lay in wait in the woods on the hill above.
Another body of pikemen were positioned in Doran's

Wood. Here they waited in ambush for Stapleton's arri-
val. Around five o'clock, Stapleton's column reached
Shepherd's farm. Here he called a halt and ordered some
mounted troops to reconnoitre the road ahead as far as
Saintfield. These men reached the stone bridge and
returned to report the village clear. Satisfied with this,
Stapleton ordered the march to resume. In the van of
the column were the mounted yeomanry and loyalists,
followed by the fencibles led by the Light Company
under Captain Chetwynd. The two cannon brought up
the rear. Baggage was to remain at Shepherd's farm for
the time being.

When approximately half this column had passed
between the thick hedges, the insurgents opened fire at
point blank range. Mortimer, his nephew and seven or
eight yeomen fell in the first fusillade and the column
was plunged into chaos as the vanguard fell back onto
the main body. Simultaneously, the pikemen in Doran's
Wood attacked and captured the baggage train.

Now hemmed in on the road, the infantry were easy
targets and it was thus imperative to get them deployed
onto the open ground. Chetwynd's Light Company
managed to penetrate the hedges and filtered out into
the field on their right but they were immediately
attacked by the main body of pikemen rushing down
the hill. Intense hand to hand fighting ensued and, by
sheer weight of numbers, the infantry were pushed back
onto the road. McKinstry was killed in this mêlée, as
were Chetwynd and two of his fellow Light Company
officers.

The critical point of the battle had now been reached
and Stapleton realised that he must deploy his remaining
troops and, most importantly, his artillery. He managed
to form up his troops on the right and they began to fire
at short range. Several times the pikemen sallied forth
down the hill to attack this line but accurate case shot
and musketry proved too much for the insurgents and
they fell back, leaving numerous casualties on the slopes.
After about an hour, the fighting petered out to a sullen

stand-off. Stapleton now held the initiative but his battered column was too weak for him to order a general advance. With around sixty dead and as many wounded, he retired back along the road to Comber and thence to Belfast.

The insurgents, left in command of Saintfield, buried their dead the following morning at the foot of the Presbyterian graveyard. The military were buried on a small island in the stream, known as York Island. The insurgent casualties are not known but must have at least equalled those of the military. As a result of this hard-won victory, the Rebellion of the United Irishmen in County Down was to continue.

The main event of the battle took place along the stretch of road from the gate lodge on Comber Street to the junction with the main Belfast–Downpatrick road. The best site to take in the battlefield, as it would have been seen by the insurgents, is from the sports pitches which are reached up a steep concrete path on the north side of the Comber road. From here the main body of pikemen under McKinstry and Frazer were concealed and from here they launched their devastating charge downhill into Stapleton's column.

If one walks from the Belfast Road junction along Comber Road towards Saintfield, one can still imagine the predicament of Stapleton's column caught without room to manoeuvre. Although today the road has many houses built along it, some of the thick hedges, which so effectively hid the insurgent musketeers, still remain.

For another useful viewpoint, take the Windmill Road as far as the ruin of the old windmill (in existence in 1798) and look north to the wooded hill which concealed the insurgents. From here the route of the column moving below it can also be inspected.

York Island, a small island in the middle of the stream, is still just visible at the rear of the Cotswold housing development. It was here that many of the Yorkshire Fencibles were buried.

FIRST PRESBYTERIAN CHURCH GRAVEYARD:
INSURGENT GRAVES

The church is located at the corner of Comber Street and
Main Street. The Reverend Thomas Ledlie Birch was
installed as minister at Saintfield in May 1776 and was
the incumbent during the erection of the present church.
He was a keen supporter of the American colonists and
joined the Volunteers, becoming chaplain to a local unit.

Birch was an active radical and established the first
Society of United Irishmen in County Down at his
manse Liberty Hall on 14 January 1782. In July of that year
he took an active part in the commemorating of Bastille
Day in Belfast, delivering speeches in favour of the
French national assembly and Catholic emancipation.
However, his radical politics were not shared by everyone
and it caused a schism in his congregation. Part of the
congregation petitioned the Secession (Presbyterian)
church, a separate communion, to supply an alternative
minister. It duly acceded by providing a minister for a
second congregation in October 1796.

Birch's active role in the United Irish organisation
ensured he made enemies, none more so than the local
squire, Nicholas Price of Saintfield House, who was keen
to have the minister arraigned. Birch was indicted for
seditious expressions at Down Assizes in September 1787
but acquitted. In April 1798 he was again indicted, this
time at the suggestion of Joseph Harper, for endeavour-
ing to bribe Harper with fifty pounds to waive prosecu-
tion on suspected United Irishmen and of assaulting
Harper's son. However, Birch was acquitted as Joseph
Harper was shot dead on the road to Belfast; Birch was
therefore at liberty during the course of the Rebellion in
County Down.

INSURGENT GRAVES FROM THE BATTLE OF SAINTFIELD

At the very bottom of the graveyard, a small plaque com-
memorates the Battle of Saintfield. A few metres away,
behind bushes, are the graves of two insurgents, James

McEwan and John Lowry, who died at the engagement here on 9 June. Both men were from the Killinchy area. Other insurgents who were killed are buried in unmarked plots in the area surrounding these graves.

GRAVE OF JOHN SKELLY

Halfway back up the path on the right, near the Wallace vault and behind the grave of Eleanor Skelly, is a damaged cement enclosure containing two headstones, the upper stone face down. This upper sandstone memorial was originally erected in memory of John Skelly and reads: 'Sacred to the memory of John Skelly who departed this life in July 1798 aged 34 years. Also his wife Margaret Skelly who departed this life on the 14th day of February 1849 aged 82 years'. John Skelly is recorded in the *Belfast News-Letter* as having been a farmer from Creevytenant. He was tried for treason and for having a command in the insurgent army. Following a guilty verdict he was sentenced to death; this sentence was carried out on 21 July 1798. Local tradition also relates that he had in his possession stolen items from Saintfield House, the nearby estate of the local landlord, Nicholas Price, and that it was Price who had intervened to ensure a capital sentence was secured.

MEMORIAL ERECTED BY RICHARD FRAZER

About 10 m away is a leaning, red sandstone grave marker erected by Richard Frazer of Ravarra, County Down, to his son John, lately of Savannah, USA, who died in June 1825 aged thirty. A 'Colonel' Richard Frazer of Ravarra is mentioned as having been in command of the main body of pikemen hidden in the woods above the Comber Road where Stapleton's force was ambushed. On 18 July his name appears on a public notice listing insurgents, together with a fifty-guinea reward for their apprehension. The coincidence of the name is surely evidence of a link between the battle and the headstone.

SWORD AND BLUNDERBUSS

The church also preserves two weapons on the premises: a sword and a blunderbuss. The blunderbuss, which has a 30 mm muzzle, is approximately 750 mm long with a flintlock firing arrangement and a bayonet housed below the barrel. The sword, manufactured in London, has a 650 mm blade. A bugle engraved on the blade would suggest that it belonged to an officer in a light infantry unit and, given the prominence of light infantry at the Battle of Saintfield, we may postulate that it belonged to one of the fallen officers commemorated at Comber parish church.

CRAIGNASASONAGH (CARRICKNASESSNA)

THE McKEE ATROCITY

OS Sheet 20, 387599
Take the B6 Lisburn Road west out of Saintfield for
approximately 1.5 km (1 mile). Then, at a minor crossroads, turn
right into Craigy Road. About 400 m on the left is a large house
and farmyard. The McKee house comprises what is now an
outhouse of the farm, facing the road.

The McKees were a notorious loyalist family who had terrorised the neighbourhood by carrying firearms and challenging wayfarers on the road. In March 1797, Hugh McKee tried to have eleven of his neighbours hanged on a charge of attacking his home. One of those accused, James Shaw, was a cotton manufacturer from Saintfield.

On Saturday 9 June, the house was besieged by United Irishmen, chiefly from the Killinchy district, who attacked in two groups. The first party was led by the Saintfield surgeon, John McKibben, and the second by the above James Shaw, who had been indicted in the previous year. Despite a heroic resistance from within, the house was set on fire. All eleven occupants (McKee, his

wife, five sons, three daughters and a blind servant girl) died in the inferno. After the Rebellion twelve men were hanged for this crime, one of the very few recorded atrocities attributed to the United Irishmen in Ulster. Strangely, only one of the twelve was local, William McCaw of Carricknasessna; the remainder came from the Killinchy and Balloo areas.

KILLYLEAGH PARISH CHURCH

MEMORIAL TO THE
REVEREND JAMES CLEWLOW

OS Sheet 21, 528527
Return to Saintfield and take the B6 to Killyleagh, passing the castle and continuing to the junction with the main A22. Turn left towards Comber and after 100 m turn right and proceed on up to the towered parish church. The memorial tablet of white marble is located on the south side of the choir inside the church. The church is normally locked but can be viewed by arrangement with the local minister.

To the memory of Reverend James Clewlow, late vicar of the Parish of Saintfield . . . who died at Saintfield glebe on the 19th day of November 1809 in the 52nd year of his age . . .

This memorial was erected by Clewlow's widow. The Reverend James Clewlow lived at the old vicarage at Lisdalgan just west of Saintfield, where he was vicar. Both he and the local squire, Nicholas Price, were magistrates at the time of the Rebellion and collaborated in the vigorous prosecution of any known insurgent. During the insurgent occupation of Saintfield, it is recorded that he lost furniture and wines from his home. The *Belfast News-Letter* records that Robert Heasty was tried on suspicion of having robbed Clewlow's house and stolen a prayer book. He was found guilty and sentenced to three hundred lashes.

Local lore records that United Irishmen would secrete their pikes in the thatch of outhouses near his property,

believing that no one would consider searching so close to this confirmed loyalist.

On the east wall of the south transept is a memorial to James Stevenson Blackwood, Baron Dufferin and Clandeboye, who was colonel of the Royal North Down Regiment of militia during the Rebellion. His brother, commemorated by another plaque, was Vice-Admiral Sir Henry Blackwood, Bart, who fought at the Battle of Trafalgar in 1805.

DOWNPATRICK PARISH CHURCH

GRAVE OF THOMAS RUSSELL

OS Sheet 21, 486447
Take the A22 to Downpatrick. The parish church is in Church Street but is best approached via Church Avenue, which is off English Street. The gravestone is a horizontal slab on the left of the path, about 10 m from the west door of the church.

Thomas Russell was born in County Cork in 1757. A devout Anglican, he was a prime mover in the formation of the United Irish movement in Belfast in 1791. He became the second secretary of the Belfast Society for Promoting Knowledge, established in 1788 and later known as the Linen Hall Library.

Russell was appointed adjutant-general of the County Down United Irishmen but was arrested in September 1796 and incarcerated during the period of the Rebellion. He was released in 1802 and travelled to Paris where he met Robert Emmet and together they planned a second United Irish rebellion. However, events had moved swiftly since 1798 and on his return to County Down, in 1803, his planned insurrection failed utterly due to lack of support. Captured soon after, he was court martialled and hanged outside Downpatrick gaol, his head being struck off as was common for convicted traitors. His remains were buried in the parish church where later his close friend Mary Ann McCracken was to place the

headstone we see there today.

BALLEE PARISH CHURCH

GRAVE OF RICHARD STITT

OS Sheet 21, 532411
From Downpatrick take the B1 Ardglass Road, turning left at the
sign for Ballee, about 3 km (2 miles) out of the town. Proceed to a
minor crossroads and turn right. The square-towered parish church
is about 300 m down this road. Stitt's grave is marked by a large
wall plaque, straight ahead through the gate at the far wall, beneath
a large chestnut tree.

This memorial, erected by Stitt himself, records many
of his family. It also includes the inscription: 'Richard
Stitt, First Captain of Cavalry in the Newtownards
Yeomanry, the erector of this monument. He departed
this life April 1859 aged 85 years.'

Presumably Stitt was a captain at the time of the 1798
Rebellion but this cannot be confirmed by any other
source. The yeomanry were raised in 1796 but most were
stood down after the Rebellion at the end of 1798. When
hostilities began again with France in 1803 many units
were recalled but most were again disbanded by the end
of 1815.

DOWN COUNTY MUSEUM

ARTEFACTS RELATING
TO THE REBELLION

OS Sheet 21, 483446
From Ballee parish church, retrace your steps back to the centre of
Downpatrick. Signposted from the town centre, Down County
Museum is located about 250 m along English Street on the right.

The museum here occupies the former gaol building
erected between 1789 and 1796. Surrounded by high walls

it contains the governor's house and a three-storey gaol block containing cells which have been restored to their former condition. However, it had a short life span and by 1830 the gaol had become the barracks of the South Down Militia. It was superseded by a new gaol, built on the site of the present Down High School. The museum holds many static displays including some excellent exhibits relating to the United Irishmen and the 1798 Rebellion. These include: a copy of the *Northern Star* front page, dated 'Wednesday April 18th to Saturday April 21st 1792', price two pence; a copy of *A Narrative of the Confinement and Exile of William Steele Dickson DD*, written in September 1811; a cross belt plate of the Royal Castlewellan Infantry (yeomanry); a pike head; a uniform jacket of the Downshire Militia; buttons from a uniform of the Inch Infantry, later made into cuff-links; a model of Betsy Gray.

In the gaol block annex building there is a permanent display dedicated to the prisoners of the gaol. The most famous was, of course, Thomas Russell, who was incarcerated here prior to his trial. The exhibition includes a facsimile of the jury's verdict at the trial, together with their signatures, dated 20 October 1803. Cortlandt Skinner (see pp. 77–8) and James Rose-Cleland appear on the jury list. Before leaving the gaol it is worth inspecting the entrance gate. Russell was hanged from ropes suspended from two holes in the lintel above the entrance and not, as often depicted, from a gallows erected outside the gaol.

In the vestibule of the nearby Downpatrick cathedral hangs the original flag of the Echlin Volunteers, raised on 19 October 1778.

EAST DOWN II

This tour traces the final stages of the Rebellion in County Down following the initial success of the insurgents at Saintfield on 9 June. It begins at Creevy Rocks just outside Saintfield and takes in the sites associated with the Battle of Ballynahinch, continuing through the countryside of mid-Down and concluding at Lisburn.

From Belfast it is possible to proceed along the route taken by General Nugent as he set off towards the insurgent camp on the morning of 12 June. The old road to Saintfield, now a minor road passing over Ouley Hill, begins in Carryduff (OS Sheet 20, 371650).

KILLYNURE BRIDGE

OS Sheet 20, 375638
*About 1.5 km (1 mile) south of Carryduff is a concrete bridge across
a small stream. This is the successor of the original bridge which
stood here in 1798.*

Although the exact site is uncertain, the *Belfast News-Letter* records, in its Friday 13 July 1798 edition, the trial of four men: Robert Boyd, John Fulton, William Marshall Senior and William Marshall Junior. They were accused of breaking down Killynure Bridge to prevent the artillery marching against the rebels at Saintfield. Boyd, Fulton and Marshall Senior were found guilty and transported. Marshall Junior was acquitted.

CREEVY ROCKS

OS Sheet 20, 399574
*Proceed to Saintfield village and turn right on to the A21
Ballynahinch Road. After about 0.75 km (0.5 miles) turn left onto
the Drumnaconnel Road. After another 0.75 km (0.5 miles) the
rocky eminence of Creevy Rocks can be seen on the left.*

Following their victory at Saintfield on 9 June, the

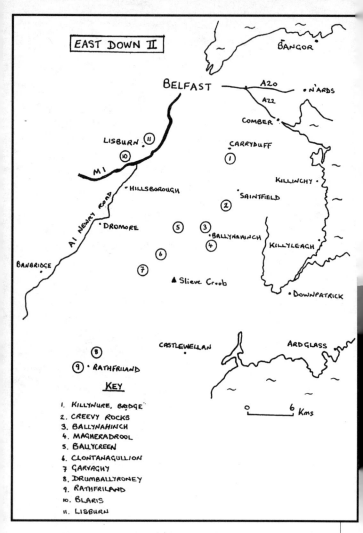

EAST DOWN II

KEY

1. KILLYNURE BRIDGE
2. CREEVY ROCKS
3. BALLYNAHINCH
4. MAGHERADROOL
5. BALLYCREEN
6. CLONTANAGULLION
7. GARVAGHY
8. DRUMBALLYRONEY
9. RATHFRILAND
10. BLARIS
11. LISBURN

0 ___ 6 Kms

victorious insurgents moved their camp to Creevy Rocks, a rocky knoll adjacent to the main road to Ballynahinch. From here, representatives were sent out to the neighbouring countryside to raise the populace into rebellion. By Monday 11 June, between five and seven thousand persons had assembled on the hillside, including a substantial contingent from Bangor, Holywood,

Newtownards and Donaghadee.

The Reverend Thomas Ledlie Birch, minister of Saint-field Presbyterian church, was present at Creevy Rocks on Sunday 10 June and is reputed to have preached a sermon to the assembled army from Ezekiel 9:1: 'He cried also in mine ears with a loud voice saying, Cause them that have charge over the city to draw near, even every man with his destroying weapon in his hand.'

Following the collapse of the Rebellion he was arrested and was charged at Lisburn on 18 June with trea-son and rebellion and 'being present, and encouraging the Rebels, at Creevy Rocks near Saintfield on Sunday evening 10th June – at Saintfield and Ballynahinch on Monday 11th – and at Mr Price's Castle, on the Terrace at the Hill, on Tuesday the 12th'.

Birch's trial occupied three full days. He denied all the charges, producing contrary evidence as to his where-abouts, and in an address prior to the verdict he thanked the court for the honourable way in which he had been treated. He explained his presence, unarmed amongst the rebels, as an attempt to prevent atrocities being com-mitted against the prisoners, for which he would claim some success. Unusually though, he asked the court to consider an offer of self-exile before deciding on their verdict. As a result, Birch was allowed to go to the United States, and settled in western Pennsylvania. Other men on lesser charges were to be hanged.

The court's leniency can be attributed to Birch's brother, George, a doctor and captain in the New-townards Yeomanry. Dr Birch evidently obtained assur-ances prior to the trial that his brother's life would be spared if he was to leave Ireland for ever.

On 11 June Harry Monro, a linen weaver from Lisburn, arrived unexpectedly at the camp at Creevy Rocks and by popular acclamation was elected as general of the insurgent army. Monro was known to the author-ities and when word arrived of the insurrection he had fled his home to escape possible arrest.

Creevy Rocks was abandoned on 11 June when Monro

moved the army to Ballynahinch where it occupied the
estate of Lord Moira at Ednavaddy Hill.

BALLYNAHINCH

BATTLE OF 12 AND 13 JUNE 1798

OS Sheet 20, 366525
The Battle of Ballynahinch was fought over a large area
covering both the town and the surrounding countryside. Several
places are pointed out here in order to give the reader a broad view
of the whole site.

Early on 11 June, Henry Monro sent James Townsend,
his second-in-command, from Creevy Rocks to occupy
Ballynahinch with a large force. Later that morning,
Monro moved the remainder of his army to Ednavaddy
Hill, south-west of the town, where he established his
headquarters. He placed units on forward positions on
Windmill Hill and Bell's Hill, north of Ballynahinch,
to cover the approaches from Belfast. Meanwhile the
government troops were preparing to close in on Monro.
At nine o'clock on 12 June, General Nugent, commander
of all forces in the north of Ireland, set out from Belfast
with the Fife Fencible Infantry, Monaghan Militia, sixty
of the 22nd Dragoons and six six-pounder cannon,
manned by regular artillerymen. He sent orders to
Colonel Stewart at Downpatrick to rendezvous with
him north of Ballynahinch with the Argyll Fencibles,
one hundred York Fencibles, Hillsborough Yeomanry
Cavalry and some Downpatrick Yeomanry Infantry. In
total, this combined force would number well over two
thousand troops.

In the late afternoon, Nugent's and Stewart's forces uni-
ted just north of Monro's forward positions and Nugent

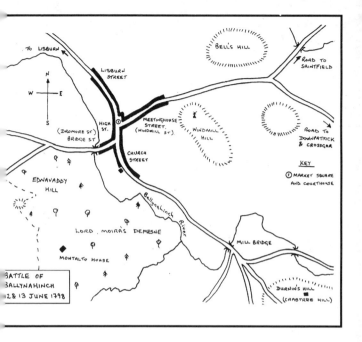

ordered the Monaghan Militia forward, supported by the artillery, to clear Bell's Hill and Windmill Hill. For an hour the insurgent musketeers contested their positions but, fearing encirclement, Monro ordered them to retire to his main position on Ednavaddy Hill. Nugent promptly occupied the vacated positions and by six o'clock his artillery were bombarding the insurgent camp at Ednavaddy. Only at around ten o'clock did Nugent allow his troops to enter Ballynahinch. However as they began to occupy the town, discipline broke down as the troops began to burn and loot valuable property and, breaking into the numerous inns, became intoxicated.

As night fell, Monro held a council of war to decide on the best course of action. According to tradition, all his subordinates urged him to attack immediately, as the

troops in the town were out of control and darkness would reduce the deadly effectiveness of long-range artillery fire. But Monro stubbornly refused to countenance a night assault and instead ordered his commanders to prepare for an attack on the town at first light. Monro was probably concerned with the difficulty of co-ordinating his poorly disciplined troops in a night attack but, in truth, he had not enough ammunition for a sustained daytime assault. His decision unnerved many of his wavering followers and whole units are reported to have marched away during the night.

Monro's plan was to launch an attack on the town from two directions simultaneously. The larger, left column was to attack up Bridge Street (now Dromore Street) engaging the enemy in a frontal attack, while a smaller second column was to cross the stream at the foot of Ednavaddy Hill and enter the town along Church Street near the present parish church, swing left and link up with the other column at the head of Bridge Street.

Despite the temporary loss of control in the town, Nugent prepared for the coming day. He sent out strong parties to block the Downpatrick and Hillsborough roads and cut off any insurgents fleeing in those directions. Then he ordered Colonel Stewart with the Argyll Fencibles, three companies of yeomen infantry, some dragoons and yeomen cavalry, strengthened by two pieces of artillery, to occupy Durnin's Hill (now Crabtree Hill) on the insurgent right flank. Finally he placed two pieces of artillery at the head of Bridge Street and positioned the Monaghan Militia in the town in preparation for an assault on Ednavaddy Hill. The rest of the troops at his disposal remained as a reserve at Windmill Hill.

Monro's artillery opened fire around three o'clock. Nugent's artillery immediately and effectively replied and the battle had commenced. This withering artillery and musket fire caused hesitation in the ranks of the insurgents and it took several attempts to persuade them

to leave the relative safety of the wooded slopes. Eventually they charged up Bridge Street and cleared it, managing to capture the two cannon there. The two columns converged and, despite heavy loss, the insurgents pressed on along High Street with a successful pike charge and reached Market Square. Though caught in a crossfire between troops occupying the court-house and those retreating down Meetinghouse Street (now Windmill Street) they were almost in control of the town. Aware of these events, Nugent decided to withdraw his remaining forces from the town and concentrate them at Windmill Hill. He ordered his bugler to sound a general retreat.

History records that Monro's weary pikemen, unfamiliar with the messages played out on the bugle, mistook the signal as an order to counter-attack. Having already suffered appalling casualties from close range musketry and cannon fire, and almost out of ammunition, the exhausted insurgents faltered and then finally lost their courage and turned tail, fleeing back down Bridge Street and into the countryside beyond.

Meanwhile Stewart's flank attack from Durnin's Hill had encountered fierce resistance. Several times his lines had been assaulted by large numbers of pikemen but each time he had managed to break up their charge at a distance. His advance eventually brought him to the base of Ednavaddy Hill at around the time the insurgents were retreating out of the town.

Monro remained on the hill with a rearguard of around one hundred and fifty men but defeat was now certain and, as encirclement was imminent, he ordered every man to make his escape. Around three hundred insurgents may have died in the battle and another two hundred in the pursuit that followed. Nugent claimed only six killed and seventeen wounded but his losses were surely more than this. More significantly, the defeat of the insurgent army at Ballynahinch effectively ended the Rebellion in Ulster.

WINDMILL HILL

The mill is located on a long whin-covered ridge on the east side of the town centre. It can be climbed from Windmill Lane or behind Windmill Avenue. This ridge featured in the battle on both days. On 12 June Monro placed a strong body of musketeers, under a man named McCance, on the hill. They blocked Nugent's approach into Ballynahinch and stalled the government's advance for over an hour. Monro recalled this detachment late in the afternoon when it was feared that the ridge might become surrounded by the advancing government troops. It was then promptly occupied by General Nugent who used it as his headquarters. On 13 June Nugent held his reserve here and used the hill's commanding position to direct the battle. From the top of the hill there are superb views northward towards Saintfield (Nugent's approach) and south and west into Ballynahinch town and beyond to Ednavaddy Hill.

COURT-HOUSE, MARKET SQUARE

The old court-house, located at one end of the square, is today a retail outlet. From here it is possible to walk along Church Street, Dromore Street, High Street and Windmill Street, where the fighting ebbed and flowed on 13 June. The houses and shops in these streets retain the frontage and possibly much of the character of the late-eighteenth-century town. It is easy to trace the main episodes in the battle, culminating in the final push of the insurgents into Market Square, the retreat of the military down Windmill Street and the subsequent mistaken message of the bugle call which led to the retreat of Monro's troops back out of the town.

EDNAVADDY HILL

Proceed down Dromore Street, across the river and after one kilometre (0.75 miles) turn left up Grove Road. From here, Ednavaddy Hill can be climbed. It is a steep scramble up an open field to the rath on the summit. Ednavaddy

Hill was chosen by Monro as his headquarters on 11 June and thousands assembled here, giving the place a kind of carnival atmosphere. And it was from here that the insurgents launched a two-pronged attack on the town on 13 June. After the battle, Nugent captured a large store of provisions and baggage, including all of Monro's artillery.

The views from the top of the hill are superb in all directions, though Ballynahinch itself is partly obscured by the woods on the eastern side of the hill.

MAGHERADROOL GRAVEYARD

GRAVE OF RICHARD CORDNER

OS Sheet 20, 379513
From Ballynahinch town centre, take the A24 towards Newcastle.
After about 1.5 km (1 mile) the road crosses Mill Bridge and two
roads diverge on the left: the B2 to Downpatrick, and Crabtree
Road. Take the latter and follow it as it climbs a steep hill. After
400 m (0.25 miles) there is a muddy lane on the left between
abandoned cottages and an electricity sub-station. The graveyard is
located at the end of the lane. Cordner's grave is within the ruined
walls of the church.

Richard Cordner was a shopkeeper in Ballynahinch during the time of the Rebellion, his shop being in High Street. On 9 June the Castlewellan Yeomanry were escorting a suspected rebel through the town, treating their prisoner rather roughly. Cordner, amongst others, witnessed this happening and left his shop to remonstrate with the yeomen. He was shot dead in the ensuing scuffle, during which the prisoner managed to escape.

BALLYCREEN

MEMORIAL TO BETSY GRAY

OS Sheet 20, 340551
From Ballynahinch, take the road west for Hillsborough, turning
off after about 1 km (0.75 miles) onto the Magheraknock Road
signposted as A49 Lisburn (note that the OS map confusingly
indicates a different road farther west as the A49). About 3 km
(2 miles) along this road turn left down Laurel Road for
approximately 500 m to the junction with Horner's Road.
Directly opposite this junction is an iron field-gate. Walk for about
150 m up the field, cross a barbed wire fence and descend into a
small, marshy hollow surrounded by whins. All that remains of
the grave are two white granite boulders.

Betsy Gray was a pretty young girl who lived at Six
Road Ends near Bangor, or at Tullynisky near
Waringsford, depending on which version of her story
you believe (though Mary Ann McCracken said Betsy
came from Killinchy). She accompanied her brother
George and sweetheart Willie Boal to the Battle of
Ballynahinch. After the battle, the three attempted to
escape on horseback but were overtaken by a party of
pursuing Hillsborough Yeomanry in Ballycreen. Pleas
for her safe conduct from the two young men were
ignored and they were promptly shot. Betsy tried to
resist but her hand was sliced off with a sword and she
was then shot through the head. The perpetrators of these
killings were Jack Gill, Thomas Nelson and James Little
of Annahilt. Gill's wife was later to be seen wearing
clothes stripped off the young girl.

Later the three bodies were carried over rocky fields
and buried in this hollow. Almost a century later a monu-
ment was erected on the site by public subscription. This
monument was destroyed in 1898 by local Protestants
incensed by the proposed centenary celebrations planned
by Catholics and Home Rulers at the grave. They argued
that Betsy's memory was being misrepresented and that
this justified their actions. Today only a few stones remain

to mark the grave of the most famous female insurgent of 1798.

CLONTANAGULLION, DROMARA

SITE OF HENRY MONRO'S BETRAYAL

OS Sheet 20, 317512
This site can be reached from Ballycreen by continuing southwards down Laurel Road and passing a series of six minor crossroads to reach the junction of the main Ballynahinch–Dromara road. At this sixth junction turn right and travel for just over 1 k (0.75 miles). McKeown's farm is on the left, down a long lane. The small outhouse formerly at the bottom of the yard was said to have been Henry Monro's last hiding place.

Henry Monro was born in 1758 and became a successful linen merchant in his home town of Lisburn. He was described as being of middle height with blue eyes and great personal strength. An Episcopalian, he was an active Volunteer and considered a major threat by the authorities. Monro was aware of his high profile and on the commencement of the uprising he left home, fearful of his safety. Thus he arrived unexpectedly at the insurgent camp on Creevy Rocks on 11 June and was unanimously elected commander.

Following defeat at the Battle of Ballynahinch, he fled into the countryside between Ballynahinch and Slieve Croob, to the south-west, accompanied by William Kean, who had been a clerk at the *Northern Star*. On 15 June the two fugitives arrived at the farm of William Holmes at Clontanagullion. Holmes agreed to conceal them in an outhouse but almost immediately betrayed their whereabouts to a group of passing soldiers. Monro and Kean were marched off, first to Hillsborough and then on to Lisburn, where Monro later stood trial. Kean was taken later to Belfast where he was imprisoned, pending trial at the New Inn. However between midnight and 1 a.m. on 2 July Kean managed to escape via a

ladder placed in the yard at the rear of the premises.
Despite a public notice warning of his escape, he mana-
ged to evade recapture. Another version holds that
Monro and Kean were spotted hiding in a potato field
by three members of the Seagoe Yeomanry. Monro
offered them forty guineas to allow himself and Kean to
escape but this was refused and they were marched off to
Hillsborough and then Lisburn.

GARVAGHY PARISH CHURCH

RIVAL CLAIM TO BETSY GRAY

OS Sheet 20, 223477
Continue into Dromara and take the road west for Banbridge
(passing the parish church of St John where William Holmes,
Monro's betrayer, is buried) to Kinallen. From there, take the
Tullinisky Road to Waringsford and passing through the hamlet,
turn left into Garvaghy Church Road. About 1.5 km (1 mile)
along the road on the right is the small parish church of Garvaghy.
Walk up the path to the rear of the church. About 20 m south is a
high-railed, unnamed enclosure. Beside it are three small, crudely
cut headstones: the middle one is dedicated to Robert Gray
who died in 1823.

Although it is widely held that Betsy Gray hailed from
near Bangor (see pp. 135–6), there has always been a
strong counter-argument that she lived in the townland
of Tullynisky, her father being the John Gray who
appears on a rental for the Waringsford estate in 1788 as
the holder of a fifteen-acre farm. This John Gray married
Rebecca Young of the same townland in June 1774 and
they had a daughter Elizabeth, born on 14 January 1780.

The gravestone visible today, and another one dated
1734, now lost, but in existence in 1914 when reported
by J.M. Macrory in his *Banbridge Household Almanac*, con-
firm the existence and longevity of the Gray connection
with the district. Unfortunately the family history does
not allow one to draw concrete conclusions and the
debate is unlikely to be fully resolved. The little church

here dates to 1699, with major repairs being carried out in 1780.

DRUMBALLYRONEY

GRAVE OF WILLIAM BRUNTY

OS Sheet 29, 210364
Proceed 6.5 km (4 miles) to Katesbridge. From Katesbridge take
the B25 to Rathfriland. After 5 km (3 miles), turn left at a minor
crossroads and continue for 1.5 km (1 mile) to the former school and
church which now form the Brontë Interpretive Centre. At the rear
of the schoolhouse is a graveyard and below the middle window
is the burying place of the Brontë family, which presumably
includes William.

William Brunty (or Prunty) was the second son of Hugh Prunty and brother of Patrick, who was later to become the father of three very famous daughters in English literature – Charlotte, Emily and Anne Brontë. Patrick was born in 1777 but William's date of birth is uncertain. William was a United Irishman and was involved in the Battle of Ballynahinch, proving that people from this area of County Down did participate, although most of the insurgents at the battle were from the north and east of the county. In his account of the Rebellion, Charles Hamilton Teeling states that there had been assemblies of insurgents at Rathfriland and Ballywillwill, but that these had not made it to the battle. It would appear that William was one of the few who did manage to reach Ballynahinch.

Following the defeat of the insurgents, William was arrested but released, presumably under parole conditions. Perhaps his youthfulness saved him from greater punishment (though compare his experience with that of William Nelson at Ballycarry, see pp. 87–8).

The Brunty home can be reached by continuing along the B25 into Rathfriland and then proceeding along the B3 for 6.5 km (4 miles), to minor crossroads. Turn right

and proceed for 1.5 km (1 mile). The ruins here on the left (signposted) represent the former home of Hugh Brunty and his family, including Patrick and William.

RATHFRILAND FIRST
PRESBYTERIAN CHURCH

GRAVE OF THE REVEREND
SAMUEL BARBER

OS Sheet 29, 197337
*Proceed to Rathfriland and make for Newry Street. This steep
street contains the First Presbyterian church, halfway along it.
Barber's grave is directly at the rear of the church, one of two raised
horizontal slabs within an enclosure.*

The faint lettering reads as follows:

The Congregation of Rathfriland Present
This Monument to their Pastor
The Rev Samuel Barber, A.M. . . .
. . . An able servant of Christ
a fearless advocate of the right of
private judgement in matters of faith
and a Steady friend of Civil and Religious
 liberty . . .

The Reverend Samuel Barber was born in 1738 at Killead, County Antrim. Licensed by Templepatrick Presbytery, he was ordained in First Rathfriland Presbyterian church on 3 May 1762. In 1771 he married Elizabeth Kennedy, eldest daughter of the Reverend Andrew Kennedy, and they had seven children of whom four were to die young. Of great physical stature (the popular jingle about the Volunteers as being 'six-foot-two, without a shoe' actually applied to him), he was also a man of considerable intellectual ability and an eloquent speaker. In 1775, he presided over the erection of a new meeting-house which survives to this day. John Wesley, who was to preach from its pulpit on 13 June 1787,

described his host as a 'princely personage' and was impressed by the 'new spacious preaching house'. Barber was an early advocate of Catholic emancipation and as the captain of the Rathfriland Volunteers from 1779, he was to actively petition on their behalf, arguing that Catholics had behaved 'peaceably and quietly, though as a religious society they have been subjected to penal laws, shocking to enumerate'.

During the sectarian disturbances of July 1792 involving the Peep o'Day Boys and the Defenders in the Rathfriland area, Barber was to work with Samuel Neilson, formerly from the district, to try to resolve the unrest. However they were to have mixed success and the problem of agrarian violence continued. Barber remained an outspoken critic of the government and his activities were watched keenly. What role he might have played in the Rebellion may never be fully known but it would appear that he was to be given a command in the area. On 8 or 9 June 1798, there is some evidence of a partial turnout at Mayobridge, to the south-west of Rathfriland and east of Newry. This area would have been significant in subsequent developments as it lay adjacent to the main Belfast–Dublin road, a vital communication link, and could have been easily cut.

However, Barber was arrested on Sunday 3 June 1798 when a large force of soldiers surrounded the meeting-house in which he was preaching. He was taken to Belfast, and later Newry, for trial. He was convicted of treason and sentenced to seven years' banishment or two years in Downpatrick gaol. He chose the latter punishment and, under guard, set off on foot to his place of confinement. A horse was subsequently provided by a Newry resident and he proceeded through Rathfriland, where an angry crowd had gathered and were threatening to set him free, but he appealed to them not to interfere and continued on his way. His daughter, Margaret, then sixteen, voluntarily remained in gaol with her father who was then over sixty years old. Barber was released before his sentence was completed and returned to his

ministry at Rathfriland where he died in 1811.

BLARIS GRAVEYARD

MONAGHAN MILITIA GRAVES

OS Sheets 15/20, 249627
Take the A1 to Lisburn. Immediately after Sprucefield roundabout
is a road to the left, marked for Blaris. The graveyard is about
1.25 km (0.75 miles) down the road on the left. The grassed area to
the right, immediately through the graveyard gate, is the unmarked
burial site of the executed Monaghan Militia men.

In February 1797, the military forces in Ireland were numbered at 15,000 regulars, 18,000 militia and 30,000 yeomanry. Despite these seemingly formidable numbers, uncertainty existed over their usefulness in any insurrection. The mainly Protestant yeomanry had only been formed a few months earlier and were untrained. The mainly Catholic militia units, organised in 1793 on a county basis, were adequately trained and equipped but their commitment to the government was questioned by many.

From the time it moved underground in 1795, the United Irish organisation derived great propaganda value by claiming to have successfully infiltrated militia regiments throughout Ireland, thereby ensuring that in any insurrection the militia's loyalty to the government could not necessarily be relied upon. This claim was substantiated in early May 1797 when Charles Leslie of Glaslough, colonel of the Monaghan Militia, discovered a conspiracy within the ranks of his regiment. This involved large numbers of soldiers taking the United Irishmen oath from unnamed persons from Belfast (Lake suspected the merchant Cunningham Greg). Leslie assembled his regiment and demanded a confession. Over seventy soldiers admitted to have taken the oath and, from these, four were identified as ringleaders. They were Owen and William McKenna, Daniel Gillen and

Peter McCarron, all from Truagh, County Monaghan.

The authorities were in no mood for leniency and were anxious to make the incident a show trial for the government's determination to face down the United Irishmen. The four men were court martialled and found guilty, the sentence by the court being execution by firing squad to be carried out on 17 May. To derive the maximum effect, the execution was staged as a solemn military occasion. Detachments of all the garrison regiments were drawn up to watch the execution and then made to file past the dead bodies.

The government's message was clear – it would not tolerate military discipline becoming compromised by any popular radical movement – and despite an outcry of sympathy in Belfast over the deaths, the executions soon had the desired effect. A few days later, Monaghan Militia men were to enter the offices of the *Northern Star* and destroy the presses, thus finally suppressing the radical newspaper. The following year the Monaghans were to demonstrate their loyalty to the government at the battles of Antrim and Ballynahinch.

LISBURN

SITE OF HENRY MONRO'S HANGING

OS Sheet 20, 269643
Proceed into the centre of Lisburn. The old market house in the
main square is now used as a local museum. The gallows were
placed against the gable facing Bow Street.

Henry Monro was tried at Lisburn on Saturday morning, 16 June, on charges of treason and rebellion. On the evidence of three insurgents, who claimed to have acted under his guidance at Ballynahinch on 13 June, he was found guilty and sentenced to death.

Monro's dignified behaviour during his trial was noted by the military officers present, including Captain William Blacker of the Seagoe Yeomanry who presided

over the court martial. Around 4 p.m. he was brought to the scaffold which was situated outside his own woollen drapery shop and home in the square. He is reported to have lightly ascended the gallows to his death. However, his execution was not a straightforward affair.

A prisoner had been brought from the gaol to perform the task of executioner. He placed Monro's head in a noose and almost immediately Monro signalled that he was ready by dropping a handkerchief to the ground (a prearranged signal) declaring to the crowd: 'Tell my country I demand better of it.' But the nervous executioner was unable to push Monro off his supporting ladder and it fell upon Captain Blacker and a sergeant in the Seagoe Yeomanry to perform the task. History records that Monro's wife and mother watched this grisly scene from a nearby window. Later Monro's head was struck off and placed on a spike on the market house.

Four others were to hang from the same gibbet: Thomas Armstrong, Dick Vincent, Thomas Maxwell and G. Crabbe.

FURTHER READING

Bailie, W.D. (ed.), *A History of Congregations in the Presbyterian Church 1610–1982*, Presbyterian Historical Society, 1984

Bardon, Jonathan, *A History of Ulster*, Blackstaff Press, 1992

Belfast News-Letter, 1798 eds on microfilm, Linen Hall Library, Belfast

Brett, C.E.B., *Buildings of Belfast 1700–1914*, Friar's Bush Press, revised ed., 1985

Clarke, R.S.J. (ed.), *Gravestone Inscriptions* (counties Down, Antrim and Belfast, various vols)

Derry, John W., *Castlereagh*, Allen Lane, 1976

Dickson, D., Keogh, D. and Whelan, K., *The United Irishmen: Republicanism, Radicalism and Rebellion,* Lilliput Press, 1993

Fitzpatrick, Rory, *God's Frontiersmen: The Scotch-Irish Epic*, Weidenfeld and Nicolson, 1989

Hanna, Ronnie, *Land of the Free: Ulster and the American Revolution*, Ulster Society, 1992

Hume, David and Nelson, John W., *The Templecorran Project: An Historic Guide to Ballycarry Old Cemetery*, Ballycarry Community Association, n.d.

Lyttle, W.G., *Betsy Gray or Hearts of Down*, Mourne Observer, 1968

McNeill, Mary, *The Life and Times of Mary Ann McCracken 1770–1866*, Allen Figgis, 1960; reprinted Blackstaff Press, 1988

Maguire, W.A. (ed.), *Kings in Conflict: The Revolutionary War in Ireland and its Aftermath 1689–1750*, Blackstaff Press, 1990

Patton, Marcus, *Central Belfast: A Historical Gazetteer*, Ulster Architectural Heritage Society, 1993

Stewart, A.T.Q., *A Deeper Silence: The Hidden Origins of the United Irishmen*, Faber and Faber, 1993

The Summer Soldiers: The 1798 Rebellion in Antrim and Down, Blackstaff Press, 1995

The '98 Rebellion, Education Facsimile 81–100, Public Record Office of Northern Ireland

INDEX